Dinosaur Origami

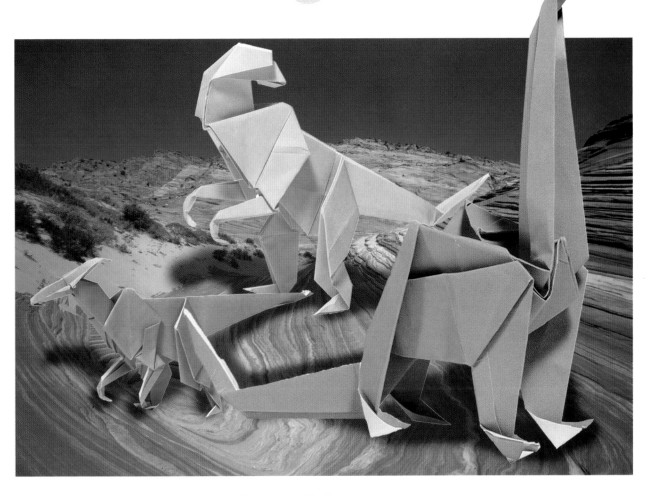

Duy Nguyen

Sterling Publishing Co., Inc.
New York

Design by Judy Morgan
Edited by Claire Bazinet

Library of Congress Cataloging-in-Publication Data Available

10 9 8 7 6 5 4 3 2 1

Published by Sterling Publishing Company, Inc.
387 Park Avenue South, New York, N.Y. 10016
© 2002 by Duy Nguyen
Distributed in Canada by Sterling Publishing
℅ Canadian Manda Group, One Atlantic Avenue, Suite 105,
Toronto, Ontario, Canada M6K 3E7
Distributed in Great Britain and Europe by Chris Lloyd at Orca Book Services,
Stanley House, Fleets Lane, Poole BH153AJ, England
Distributed in Australia by Capricorn Link (Australia) Pty. Ltd.,
P.O. Box 704, Windsor, NSW 2756 Australia
Printed in China

Sterling ISBN 0-8069-7699-3

Contents

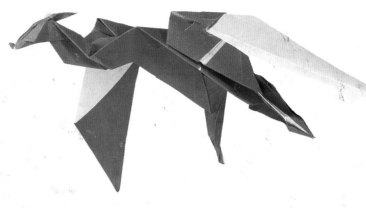

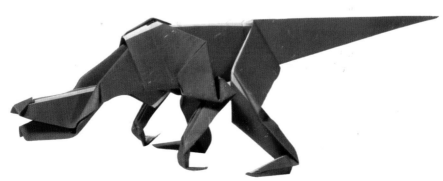

Introduction

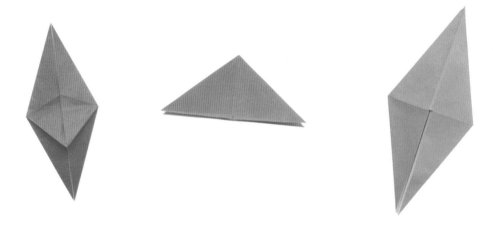

When I first started to learn origami, I struggled with even the simplest basic folds, such as the valley, mountain and pleat folds. When I tried to fold an object, I looked back to the beginning chapter again and again to see these basic folds and verify what I needed to do next. I also kept looking ahead, at the diagram showing the next step of whatever project I was folding, to see how it *should* look, to be sure that I was following the instructions correctly. Looking ahead at the "next step," the result of a fold, is very good, even necessary, for someone just beginning to learn origami.

Another way to make learning origami easier is to create "construction lines" before folding. By this I mean to pre-fold, then unfold, usually using valley or mountain folds, to crease the form. These pre-creases create guidelines for a more complex fold coming up. For example: when folding a pleat fold reverse, or inside and outside folds, if you pre-crease using mountain and valley folds, the finished fold will better match the one shown in the book. When your finished folds look different, due to fold lines being at slightly different angles, it can cause confusion and throw you off.

It is also important to make good clean fold lines. Well-made construction lines are helpful when you want to unfold the form slightly in order to make another fold easier.

As you continue folding and become more proficient at origami, these learning basics either become second nature...or unnecessary. For now, though, the above tips to learning origami should allow you to navigate through *Origami Dinosaurs* with fewer mistakes and less confusion. This book, after all, contains only the most basic techniques and folds. By following and comparing the sequenced step-by-step illustrated instructions, and carefully checking the fold symbols and lines indicated, you should have no trouble learning to make origami dinosaurs.

Duy Nguyen

Basic Instructions

Paper: The best paper to use for origami is very thin, keeps a crease well, and folds flat. It can be plain white paper, solid-color paper, or wrapping paper with a design only on one side. Regular typing paper may be too heavy to allow the many tight folds needed for some figures. Be aware, too, that some kinds of paper may stretch slightly, either in length or in width, and this may cause a problem in paperfolding. Packets of paper especially for use in origami are available from craft and hobby shops.

Unless otherwise indicated, the usual paper used in creating these forms is square, 15 by 15 centimeters or approximately 6 by 6 inches. Some forms may call for half a square, i.e., 3 by 6 inches or, cut diagonally, a triangle. A few origami forms require a more rectangular (legal) size or a longer piece of paper. For those who are learning and have a problem getting their fingers to work tight folds, larger sizes of paper can be used. Actually, any size paper squares can be used—slightly larger figures are easier to make than overly small ones.

Glue: Use a good, easy-flowing but not loose paper glue, but use it sparingly. You don't want to soak the paper. A toothpick makes a good applicator. Allow the glued form time to dry. Avoid using stick glue, as the application pressure needed (especially if the stick has become dry) can damage your figure.

Technique: Fold with care. Position the paper, especially at corners, precisely and see that edges line up before creasing a fold. Once you are sure of the fold, use a fingernail to make a clean, flat crease. Don't get discouraged with your first efforts. In time, what your mind can create, your fingers can fashion.

Symbols & Lines

| Fold lines | valley | - - - - - - - - |
| | mountain | — · — · — · — |

| Cut line | +++++++++++ |

| Turn over or rotate | |

| Fold then unfold | ←———→ |

| Pleat fold (repeated folding) | |

| Crease line | ———— |

Basic Folds

Kite Fold

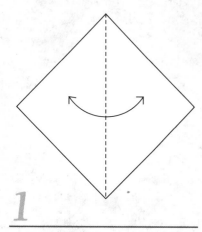

1
Fold and unfold a square diagonally, making a center crease.

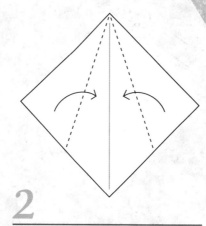

2
Fold both sides in to the center crease.

3
This is a kite form.

Valley Fold ------------------

1
Here, using the kite, fold form toward you (forward), making a "valley."

2
This fold forward is a valley fold.

Mountain Fold —-—-—-—-—

1
Here, using the kite, fold form away from you (backwards), making a "mountain."

2
This fold backwards is a mountain fold.

Inside Reverse Fold

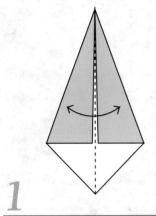

1

Starting here with a kite, valley fold kite closed.

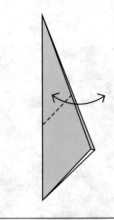

2

Valley fold as marked to crease, then unfold.

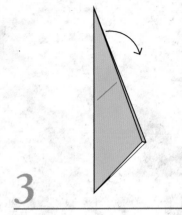

3

Pull tip in direction of arrow.

4

Appearance before completion.

5

You've made an inside reverse fold.

Outside Reverse Fold

1

Using closed kite, valley fold, unfold.

2

Fold inside out, as shown by arrows.

3

Appearance before completion.

4

You've made an outside reverse fold.

Pleat Fold

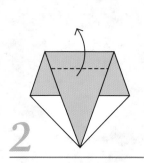

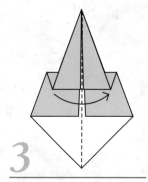

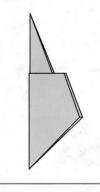

1 Here, using the kite, valley fold.

2 Valley fold back again.

3 This is a pleat. Valley fold in half.

4 You've made a pleat fold.

Pleat Fold Reverse

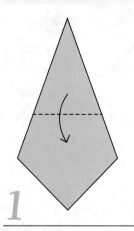

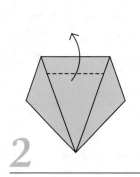

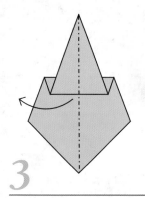

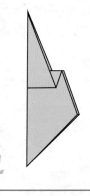

1 Here, using the kite form backwards, valley fold.

2 Valley fold back again for pleat.

3 Mountain fold form in half.

4 This is a pleat fold reverse.

Squash Fold I

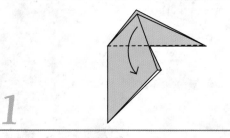

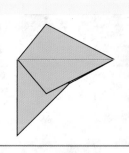

1 Using inside reverse, valley fold one side.

2 This is a squash fold I.

Squash Fold II

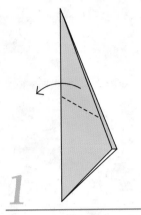

1

Using closed kite form, valley fold.

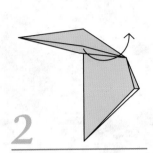

2

Open in direction of the arrow.

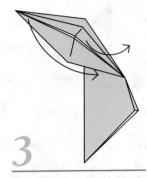

3

Appearance before completion.

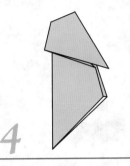

4

You've made a squash fold II.

Inside Crimp Fold

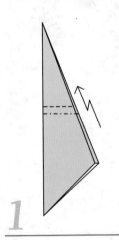

1

Here using closed kite form, pleat fold.

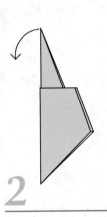

2

Pull tip in direction of the arrow.

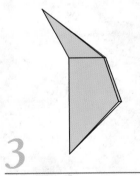

3

This is an inside crimp fold.

Outside Crimp Fold

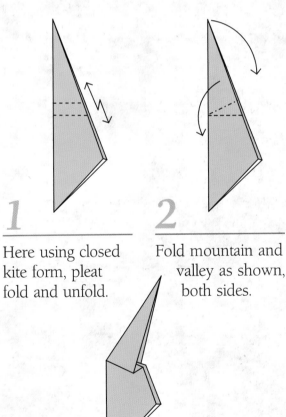

1

Here using closed kite form, pleat fold and unfold.

2

Fold mountain and valley as shown, both sides.

3

This is an outside crimp fold.

Base Folds

Base folds are basic forms that do not in themselves produce origami, but serve as a basis, or jumping-off point, for a number of creative origami figures, some quite complex. As when beginning other crafts, learning to fold these base folds is not the most exciting part of origami. They are, however, easy to do, and will help you with your technique. They also quickly become rote, so much so that you can do many using different-colored papers while you are watching television or your mind is elsewhere. With completed base folds handy, if you want to quickly work up a form or are suddenly inspired with an idea for an original, unique figure, you can select an appropriate base fold and swiftly bring a new creation to life.

Base Fold I

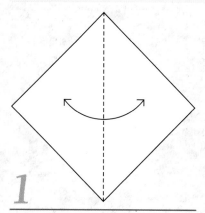

1 Fold and unfold in direction of arrow.

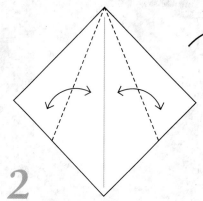

2 Fold both sides in to center crease, then unfold. Rotate.

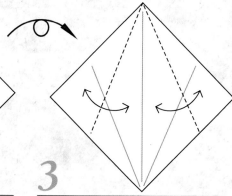

3 Fold both sides in to center crease, then unfold.

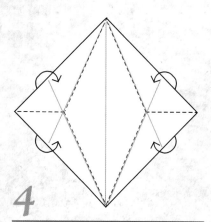

4 Pinch corners of square together and fold inward.

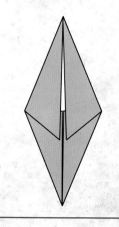

5 Completed Base Fold I.

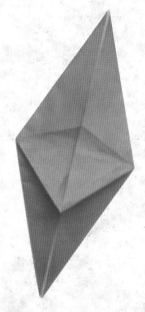

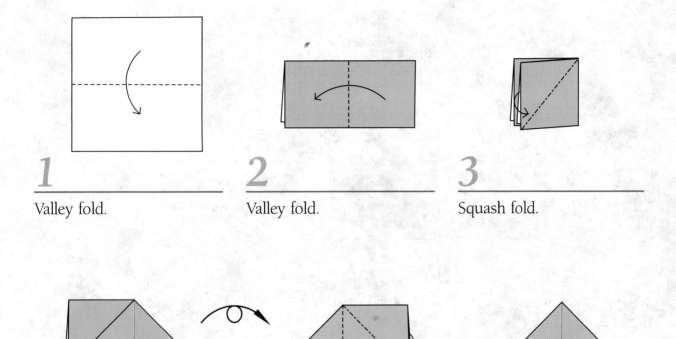

1
Valley fold.

2
Valley fold.

3
Squash fold.

4
Turn over to other side.

5
Repeat step 4.

6
Completed Base Fold II.

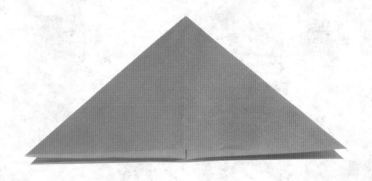

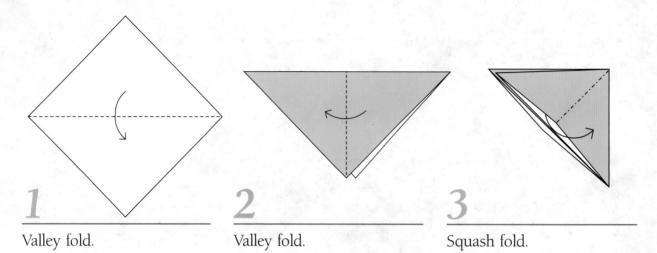

1

Valley fold.

2

Valley fold.

3

Squash fold.

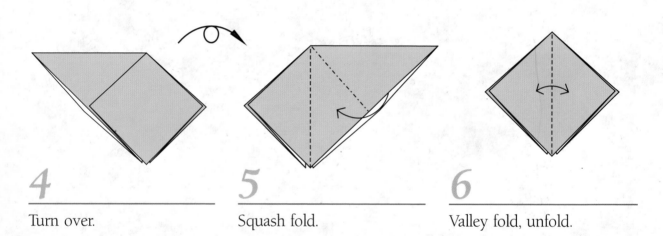

4

Turn over.

5

Squash fold.

6

Valley fold, unfold.

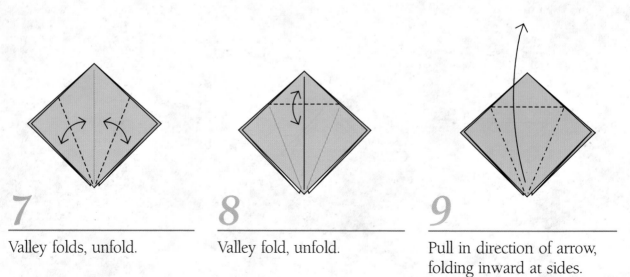

7

Valley folds, unfold.

8

Valley fold, unfold.

9

Pull in direction of arrow, folding inward at sides.

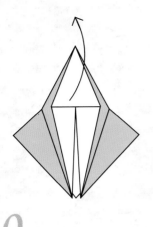

10

Appearance before
completion of fold.

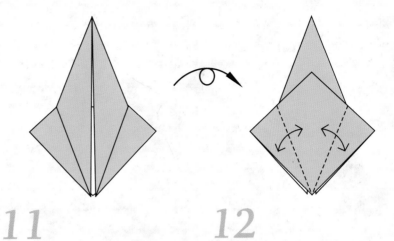

11

Fold completed. Turn over.

12

Valley folds, unfold.

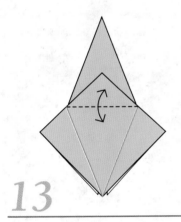

13

Valley fold, unfold.

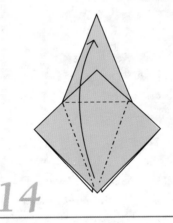

14

Repeat, again pulling in
direction of arrow.

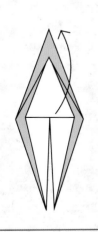

15

Appearance before
completion.

16

Completed Base Fold III.

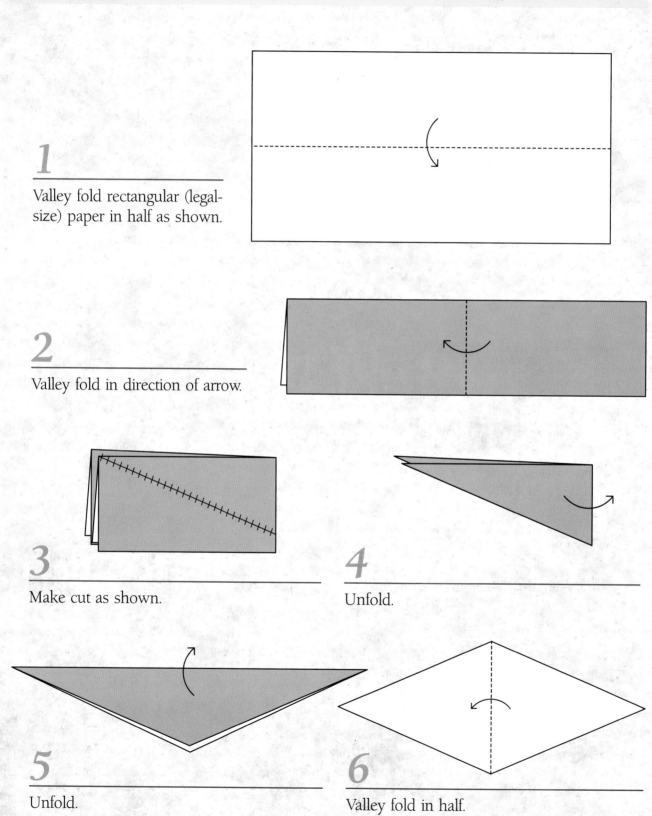

1

Valley fold rectangular (legal-size) paper in half as shown.

2

Valley fold in direction of arrow.

3

Make cut as shown.

4

Unfold.

5

Unfold.

6

Valley fold in half.

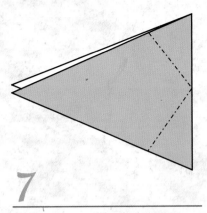

7

Inside reverse folds to inner center crease.

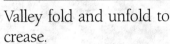

8

Valley fold and unfold to crease.

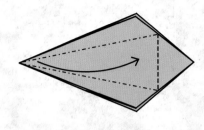

9

Pull in direction of arrow, and fold.

10

Appearance before completion.

11

Turn over.

12

Valley fold then unfold.

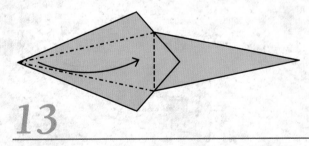

13

Again, pull in direction of arrow, and fold.

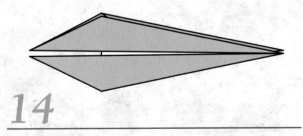

14

Completed Base Fold IV.

Brontosaur

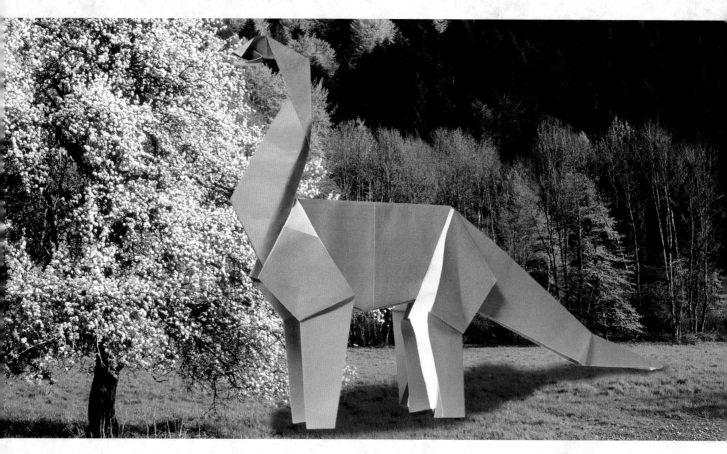

Part 1

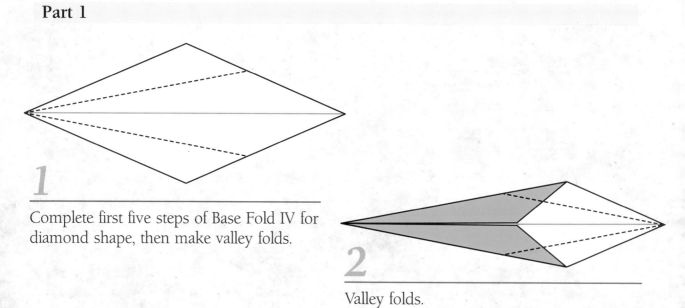

1

Complete first five steps of Base Fold IV for diamond shape, then make valley folds.

2

Valley folds.

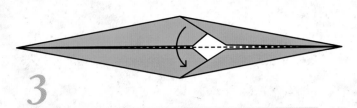

3

Valley fold in half.

4

Outside reverse fold.

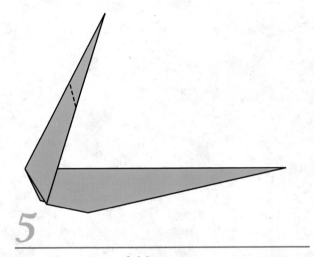

5

Outside reverse fold.

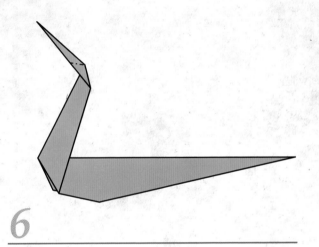

6

Inside reverse fold.

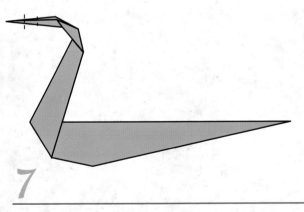

7

Pleat fold under to form mouth.

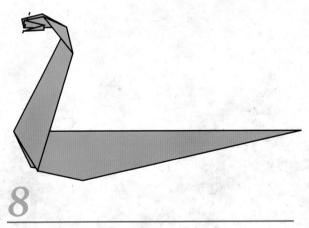

8

Valley fold both front and back.

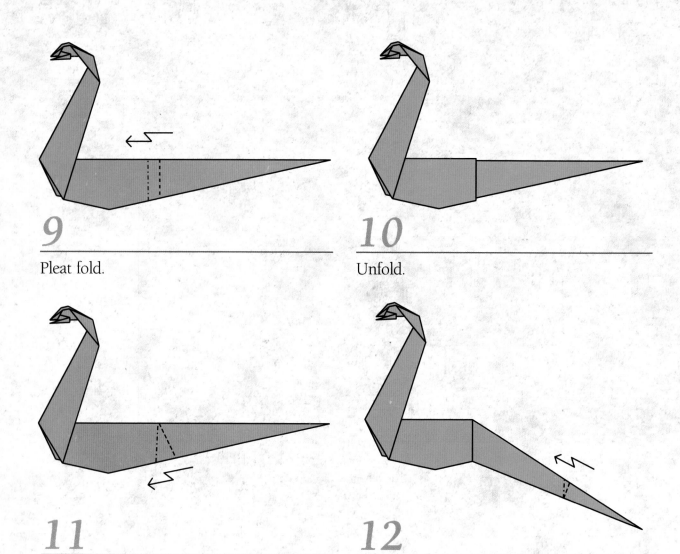

9

Pleat fold.

10

Unfold.

11

Pleat fold.

12

Pleat fold.

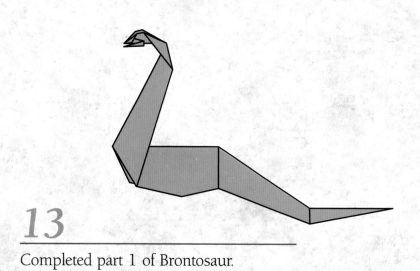

13

Completed part 1 of Brontosaur.

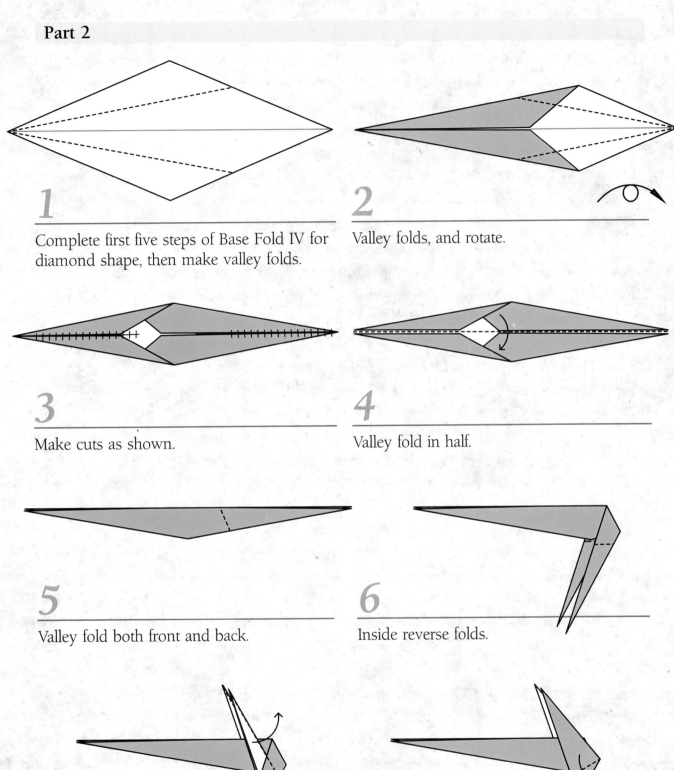

1

Complete first five steps of Base Fold IV for diamond shape, then make valley folds.

2

Valley folds, and rotate.

3

Make cuts as shown.

4

Valley fold in half.

5

Valley fold both front and back.

6

Inside reverse folds.

7

Valley fold front and back.

8

Valley fold both sides.

Brontosaur

19

9

Valley fold both front and back.

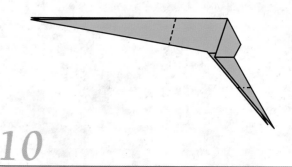

10

Valley fold both sides, inside reverse fold other end for legs.

11

Again, inside reverse fold both sides.

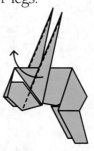

12

Then valley folds.

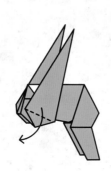

13

Valley folds again.

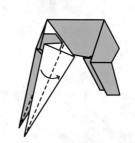

14

Valley folds.

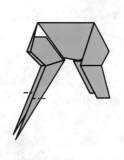

15

Inside reverse folds.

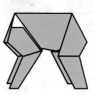

16

Completed part 2 of Brontosaur.

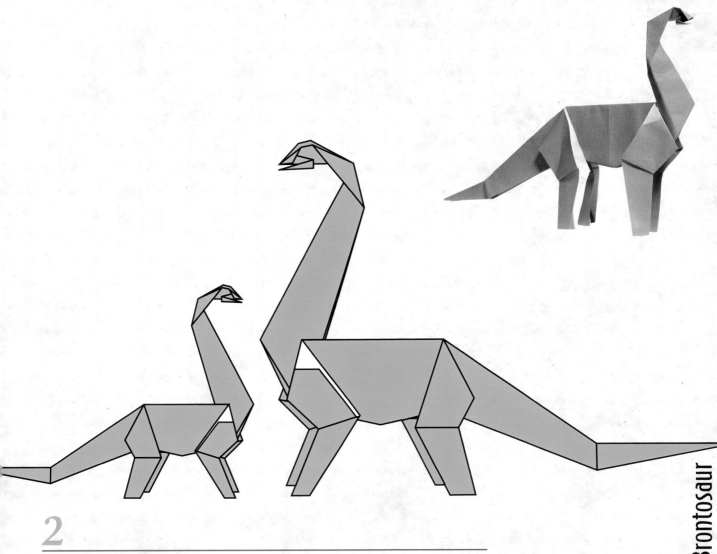

1

Join both parts together as indicated by the arrows, then apply glue to hold.

2

Completed Brontosaur

Pelycosaur

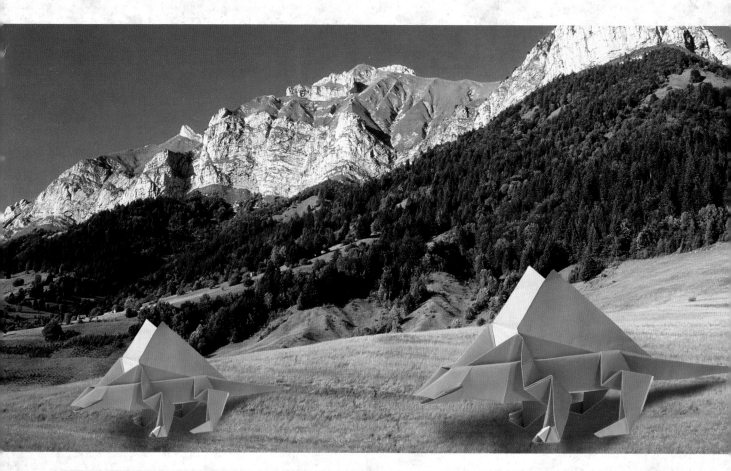

Part 1

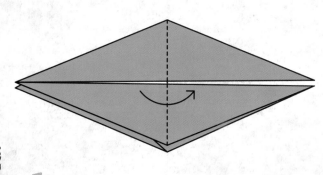

1

Start with Base Fold III, then valley fold.

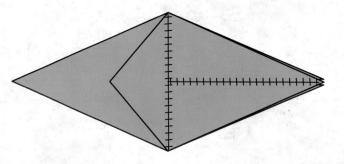

2

Cut only the front.

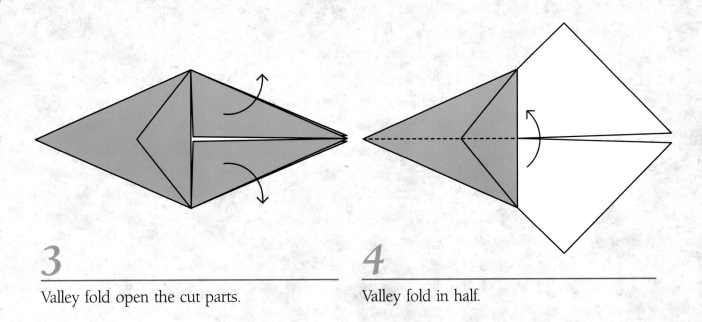

3

Valley fold open the cut parts.

4

Valley fold in half.

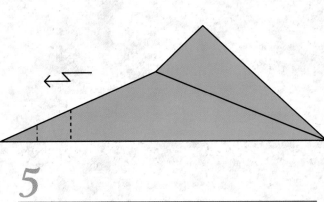
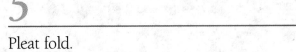

5

Pleat fold.

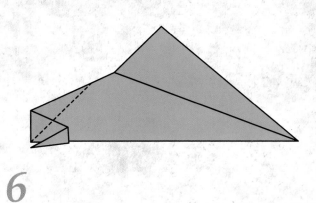

6

Valley fold both sides.

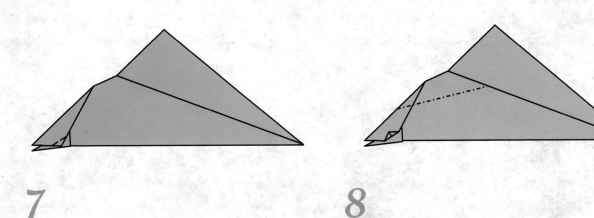

7

Valley fold both sides.

8

Mountain fold front and back.

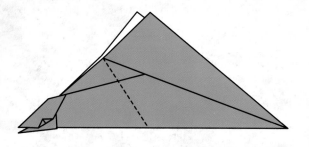

9
Valley fold both sides.

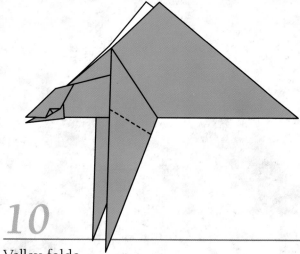

10
Valley folds.

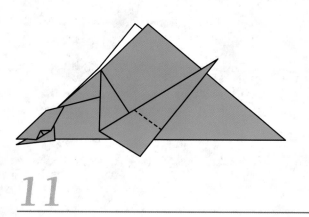

11
Valley folds.

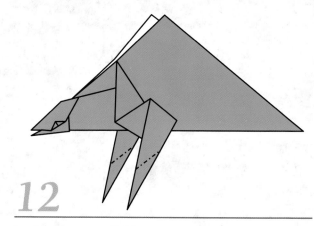

12
Inside reverse folds.

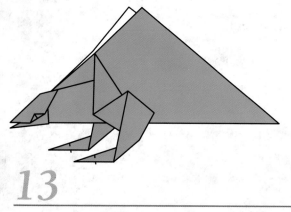

13
Outside reverse folds.

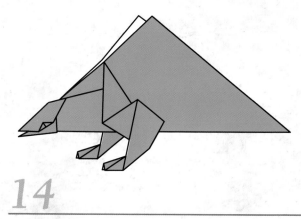

14
Completed part 1 (front) of Pelycosaur.

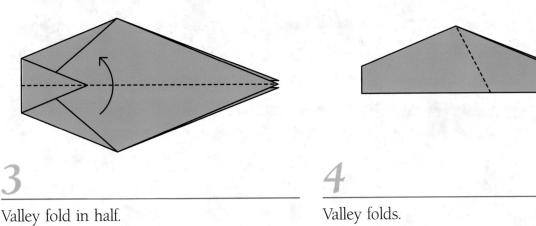

1
Start with Base Fold III, then valley fold.

2
Valley fold.

3
Valley fold in half.

4
Valley folds.

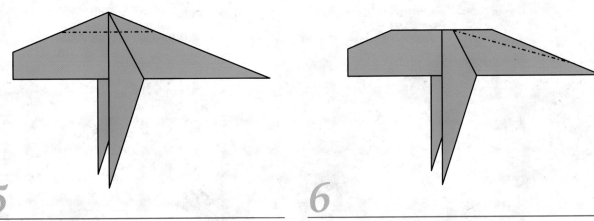

5
Mountain folds both sides.

6
Mountain folds both sides.

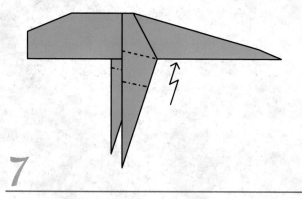

7

Pleat folds, both sides.

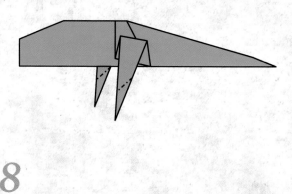

8

Inside reverse folds.

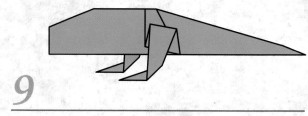

9

Completed part 2 (rear) of Pelycosaur.

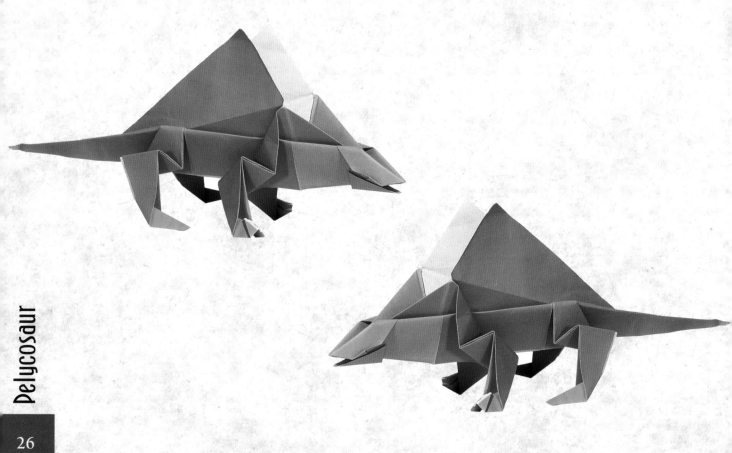

To Assemble

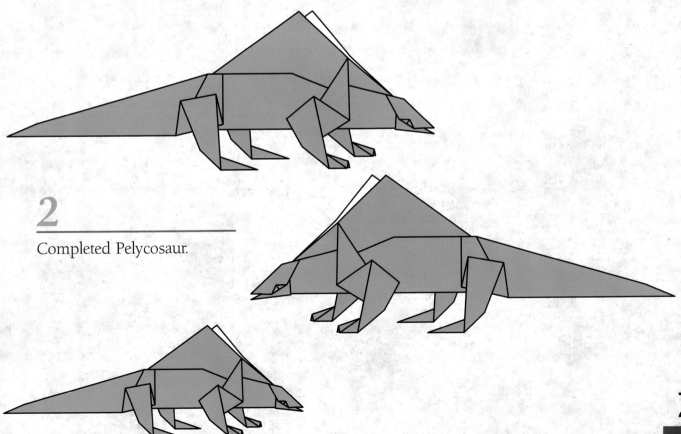

1

Join both parts together as indicated by the arrows, then apply glue to hold.

2

Completed Pelycosaur.

Velociraptor

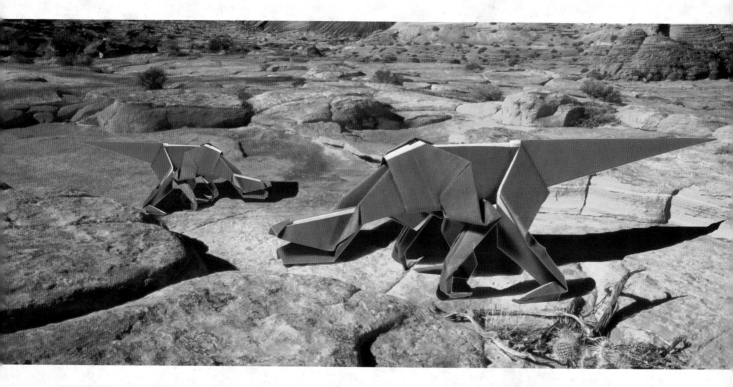

Part 1

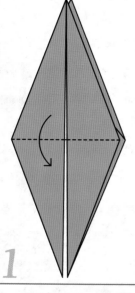

1
Start with Base Fold III, then valley fold.

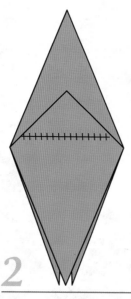

2
Cut as shown.

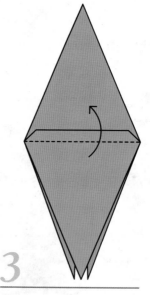

3
Valley fold.

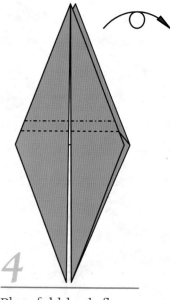

4
Pleat fold both flaps together, and rotate.

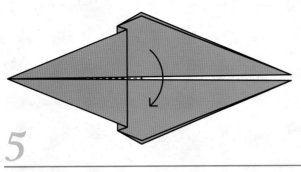

5

Valley fold in half.

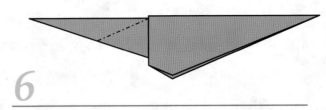

6

Inside reverse fold.

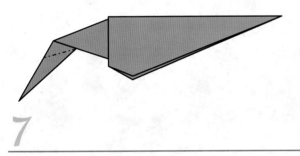

7

Inside reverse fold.

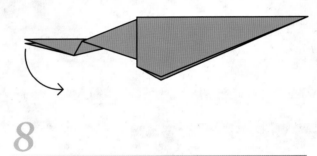

8

Pull in direction of arrow, and squash fold.

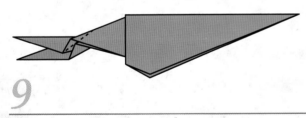

9

Valley fold front and back.

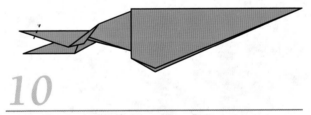

10

Outside reverse fold.

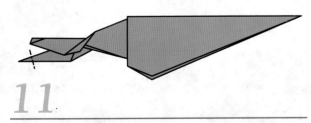

11

Inside reverse fold.

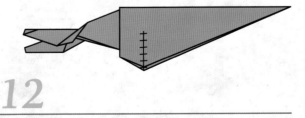

12

Make cuts to both front and back.

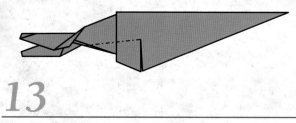

13

Mountain folds.

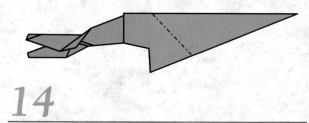

14

Inside reverse fold.

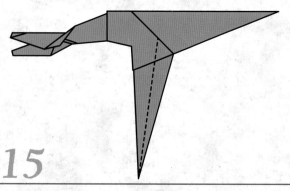

15

Valley fold front and back.

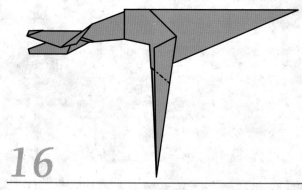

16

Inside reverse fold.

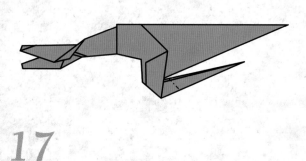

17

Inside reverse fold.

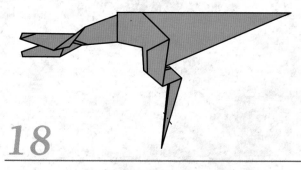

18

Inside reverse fold.

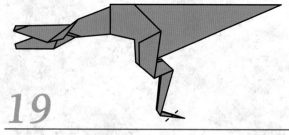

19

Outside reverse fold.

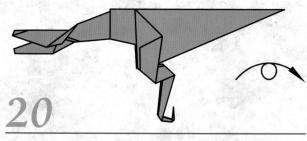

20

Turn over to the other side.

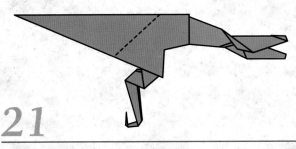

21

Repeat steps 14 to 19 on this side.

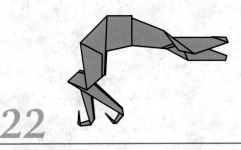

22

Completed part 1 (front) of Velociraptor.

Part 2

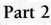

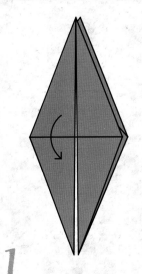

1

Start with Base Fold III. Valley fold.

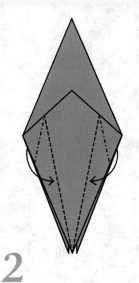

2

Squash folds.

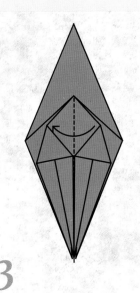

3

Valley fold.

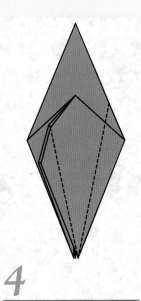

4

Valley folds.

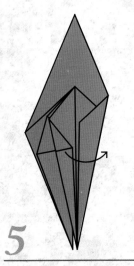

5

Valley folds.

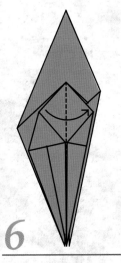

6

Valley fold.

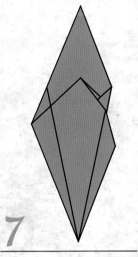

7

Valley folds.

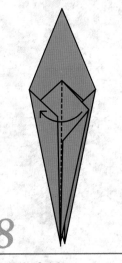

8

Valley folds.

Velociraptor

31

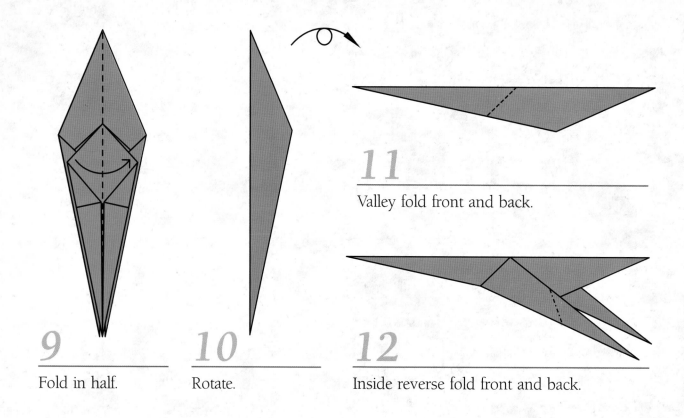

9
Fold in half.

10
Rotate.

11
Valley fold front and back.

12
Inside reverse fold front and back.

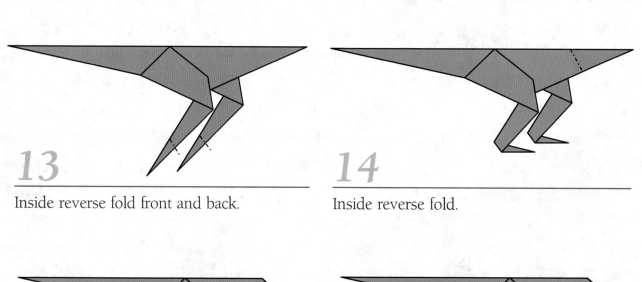

13
Inside reverse fold front and back.

14
Inside reverse fold.

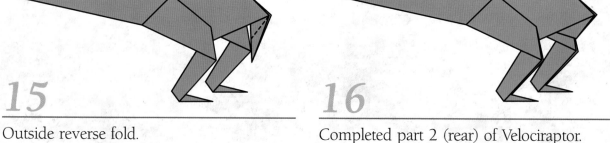

15
Outside reverse fold.

16
Completed part 2 (rear) of Velociraptor.

To Attach

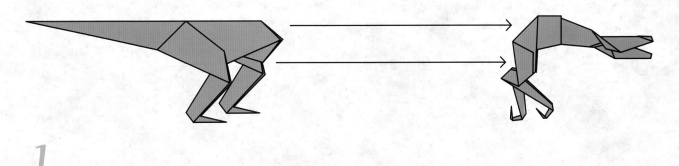

1

Join both parts together as indicated by the arrows, then apply glue to hold.

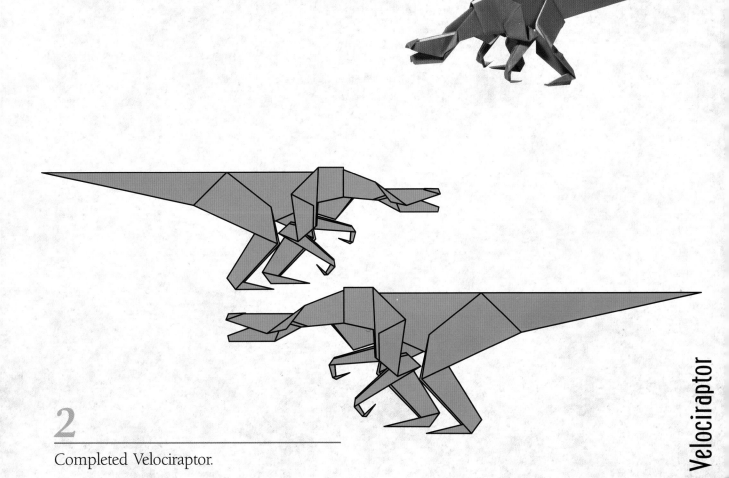

2

Completed Velociraptor.

Triceratops

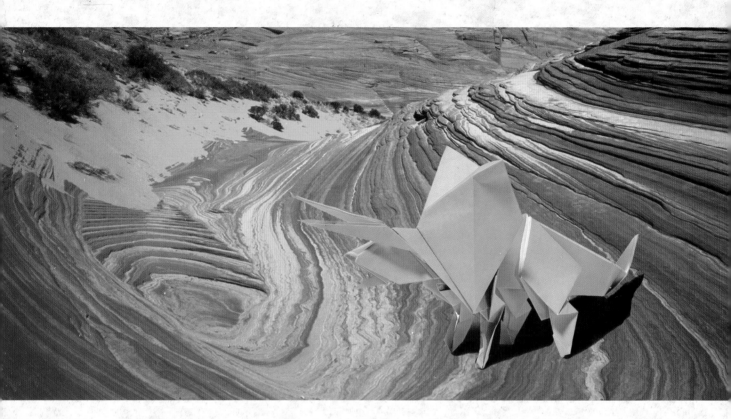

Part 1

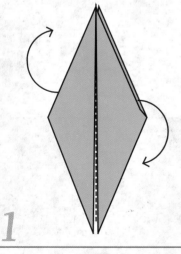

1
Start with Base Fold III.
Valley folds front and back.

2
Cut both sides.

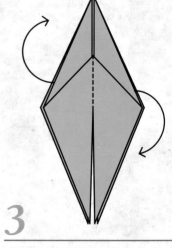

3
Valley folds front and back.

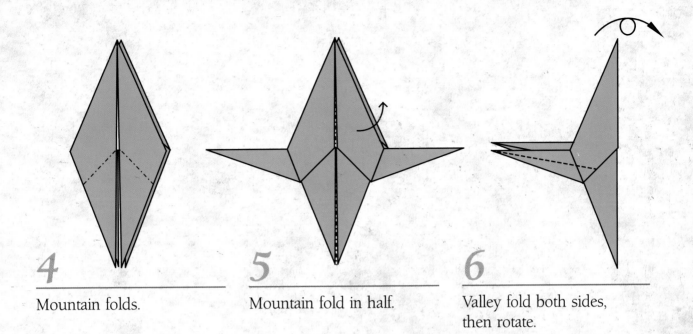

4

Mountain folds.

5

Mountain fold in half.

6

Valley fold both sides, then rotate.

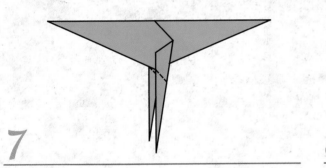

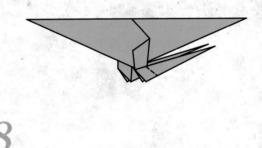

7

Outside reverse folds.

8

Outside reverse folds front and back.

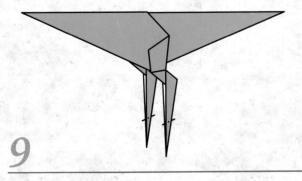

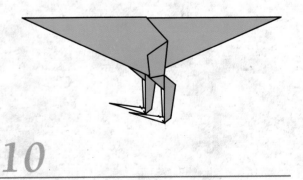

9

Inside reverse folds.

10

Outside reverse folds.

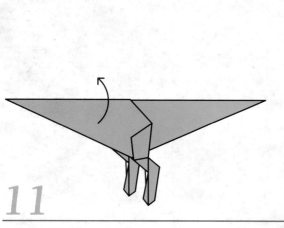

11

Valley fold open.

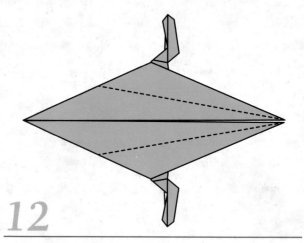

12

Valley folds.

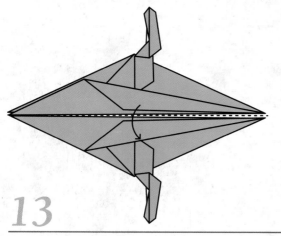

13

Valley fold.

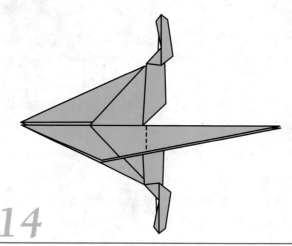

14

Valley folds front and back.

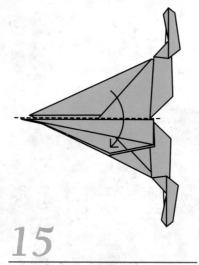

15

Valley fold in half.

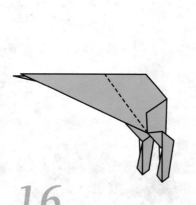

16

Outside reverse fold.

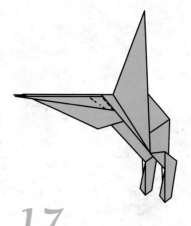

17

Pleat folds.

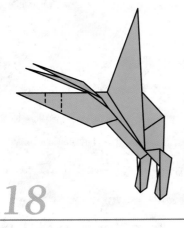

18
Pleat fold.

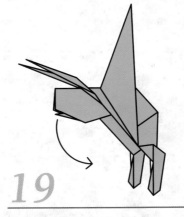

19
Pull and squash fold.

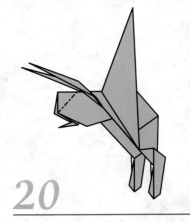

20
Inside reverse fold.

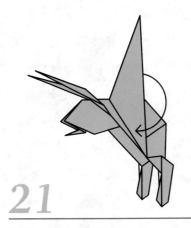

21
Pull some paper out.

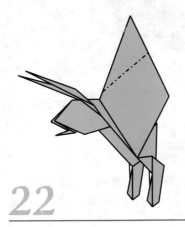

22
Inside reverse fold.

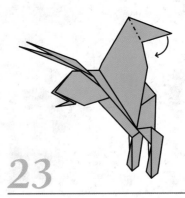

23
Mountain fold under.

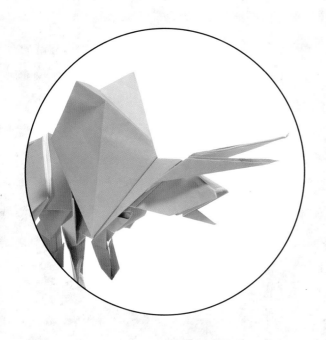

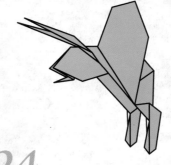

24
Completed part 1 (front) of Triceratops.

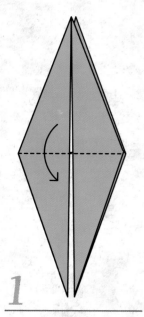

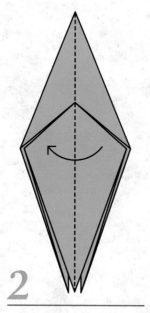

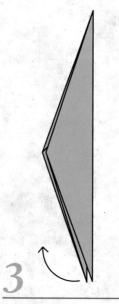

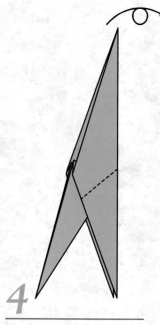

1

Start with Base Fold III. Valley fold.

2

Valley fold in half.

3

Pull in direction of arrow. Squash fold.

4

Valley fold front and back, then rotate.

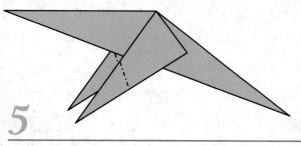

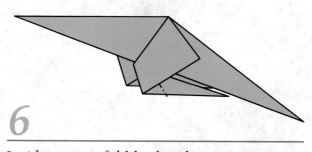

5

Inside reverse fold front and back.

6

Inside reverse fold both sides.

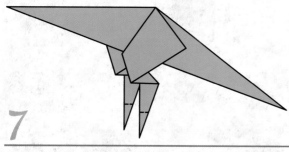

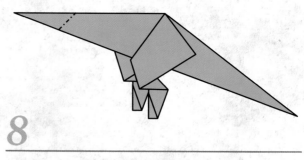

7

Outside reverse fold, front and back.

8

Inside reverse fold.

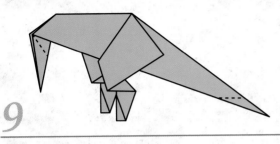

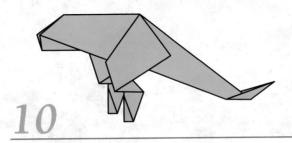

9

Outside reverse folds.

10

Completed part 2 (rear) of Triceratops.

To Assemble

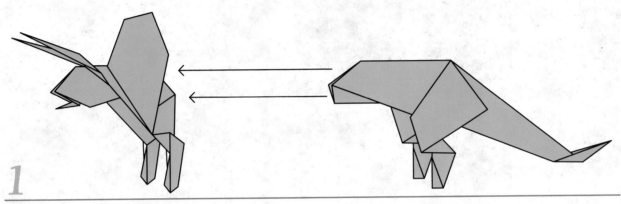

1

Join both parts together as indicated, then apply glue to hold.

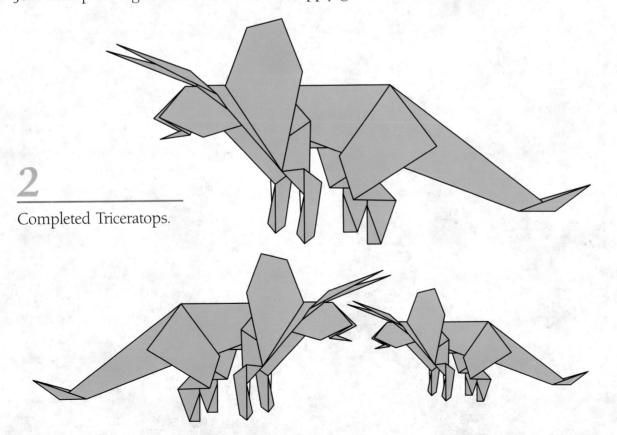

2

Completed Triceratops.

Tyrannosaur

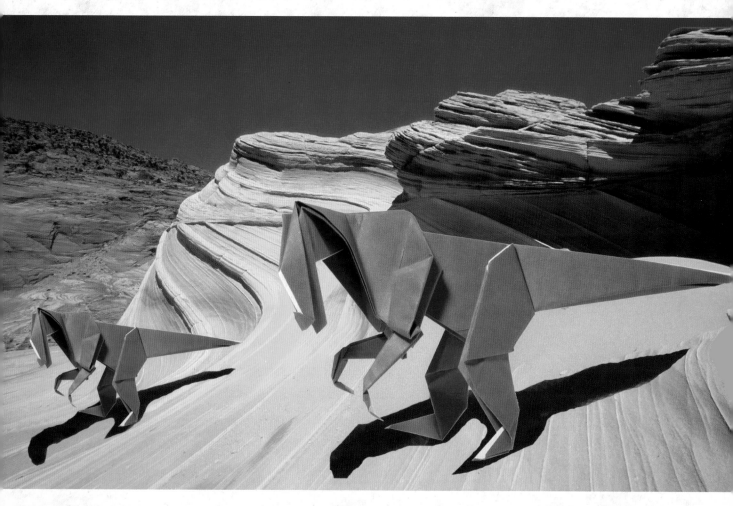

Part 1

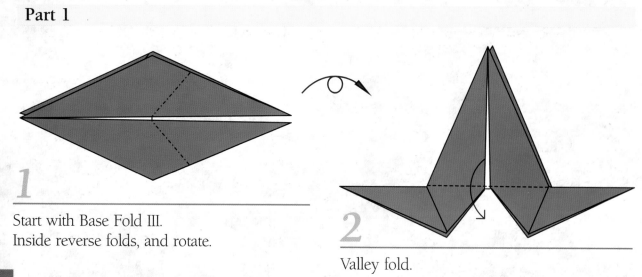

1

Start with Base Fold III.
Inside reverse folds, and rotate.

2

Valley fold.

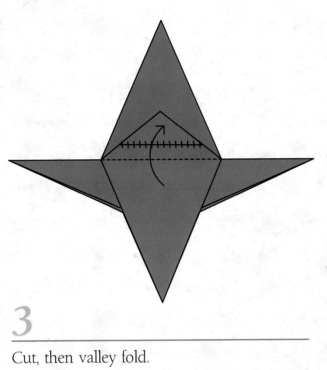

3

Cut, then valley fold.

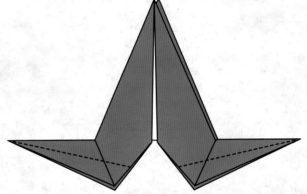

4

Valley folds.

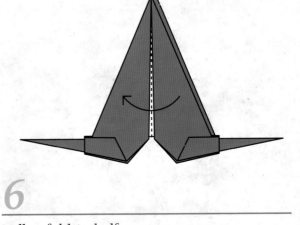

5

Pleat folds.

6

Valley fold in half.

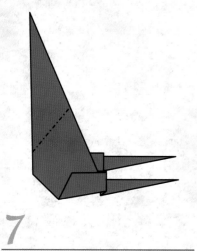

7

Inside reverse fold.

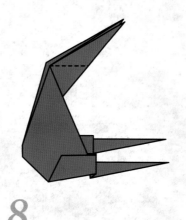

8

Outside reverse fold.

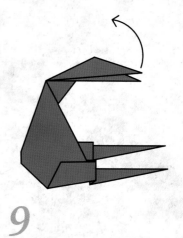

9

Pull up and squash fold.

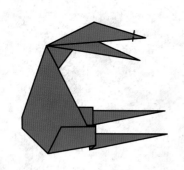

10

Outside reverse fold.

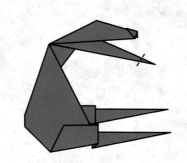

11

Inside reverse fold.

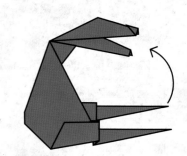

12

Pull up and squash fold.

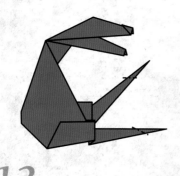

13

Inside reverse folds.

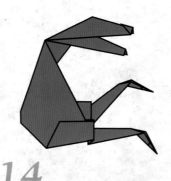

14

Outside reverse folds.

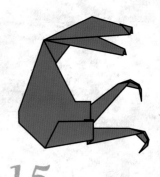

15

Completed part 1 (front) of Tyrannosaur.

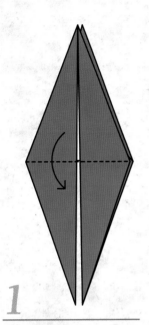
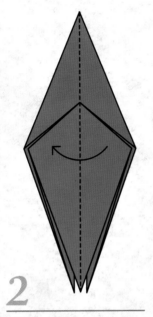
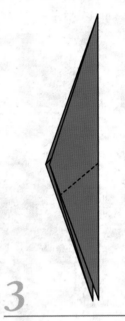
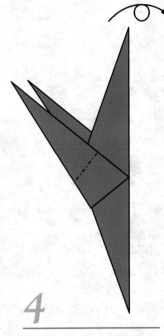

1
Start with Base Fold III. Valley fold.

2
Valley fold in half.

3
Valley fold front and back.

4
Inside reverse fold front and back, then rotate.

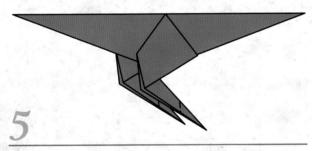
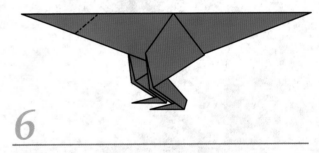

5
Inside reverse fold front and back.

6
Inside reverse fold.

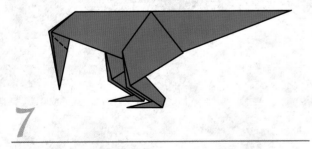
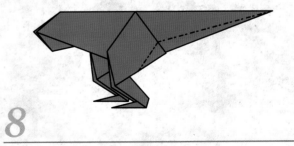

7
Outside reverse fold.

8
Mountain fold front and back.

Tyrannosaur

9

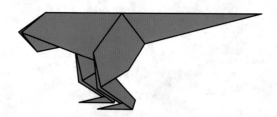

Completed part 2
(rear) of Tyrannosaur.

To Assemble

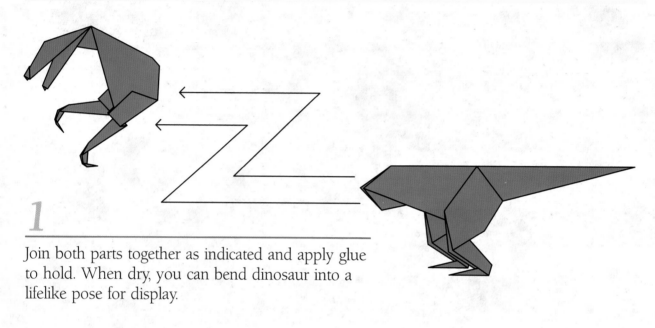

1

Join both parts together as indicated and apply glue
to hold. When dry, you can bend dinosaur into a
lifelike pose for display.

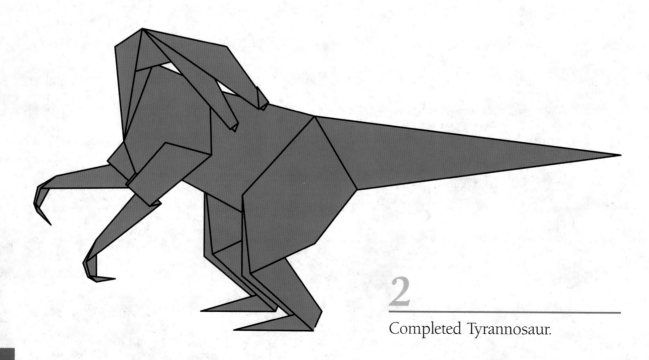

2

Completed Tyrannosaur.

Tyrannosaur

Stegosaur

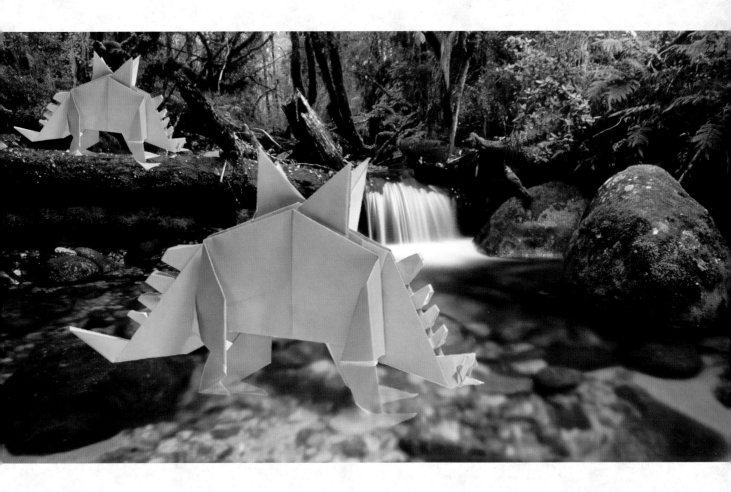

Part 1

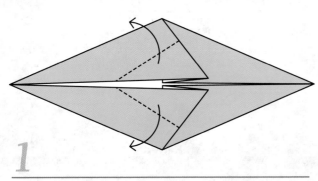

1

Start with Base Fold I. Valley folds and squash folds (see next diagram).

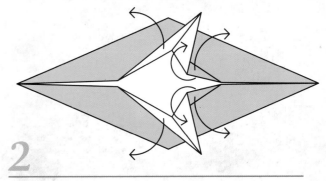

2

Appearance just before completion.

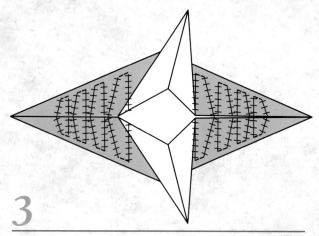

3

Make cuts as shown, then valley fold out.

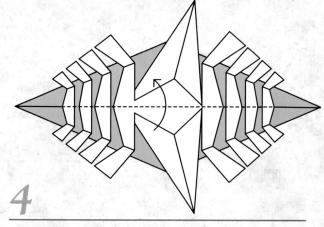

4

Valley fold in half.

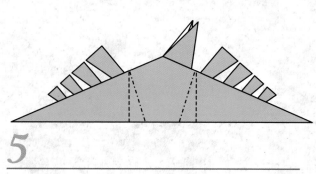

5

Pleat folds.

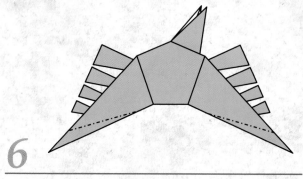

6

Inside reverse folds.

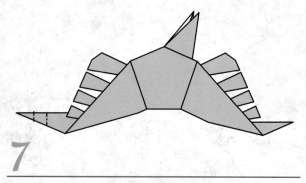

7

Pleat fold, forming "mouth."

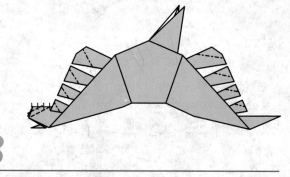

8

Cut and pleat fold both sides of "head,"
mountain fold down "body" as shown.

9

Completed part 1 (head and
back) of Stegosaur.

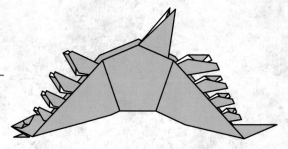

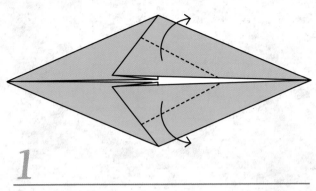

1

Start with Base Fold I. Make valley folds, then squash.

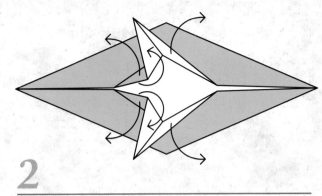

2

Appearance just before completion.

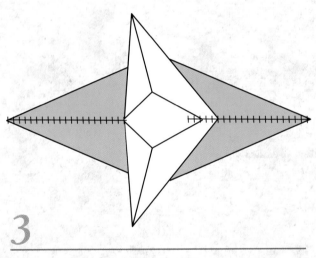

3

Make cuts as shown.

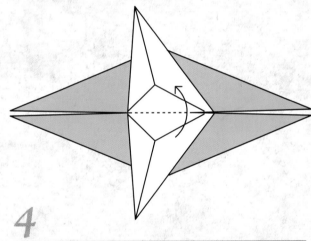

4

Valley old in half.

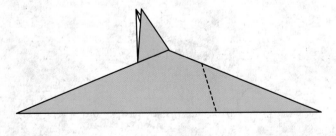

5

Valley fold both front and back.

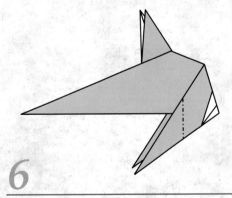

6

Mountain fold both sides.

Stegosaur

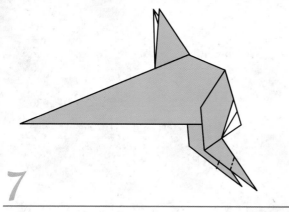

7

Inside reverse fold both front and back.

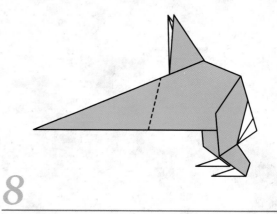

8

Valley fold.

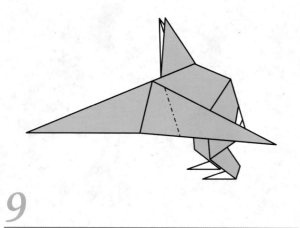

9

Mountain fold.

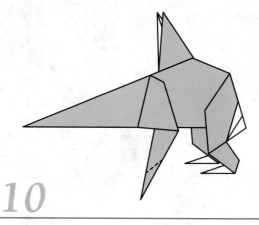

10

Outside reverse fold.

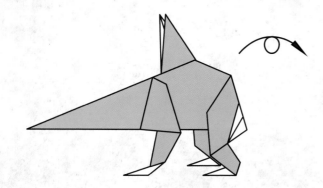

11

Turn over to the other side.

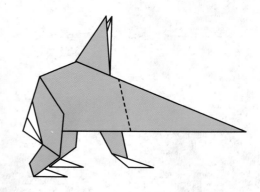

12

Valley fold.

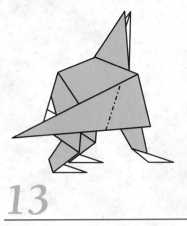

13

Mountain fold.

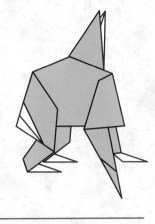

14

Outside reverse fold.

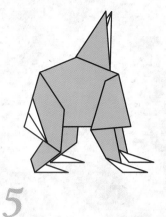

15

Completed part 2 (body) of Stegosaur.

To Assemble

1

Lower part 1 into center of part 2 as shown, and apply glue to hold.

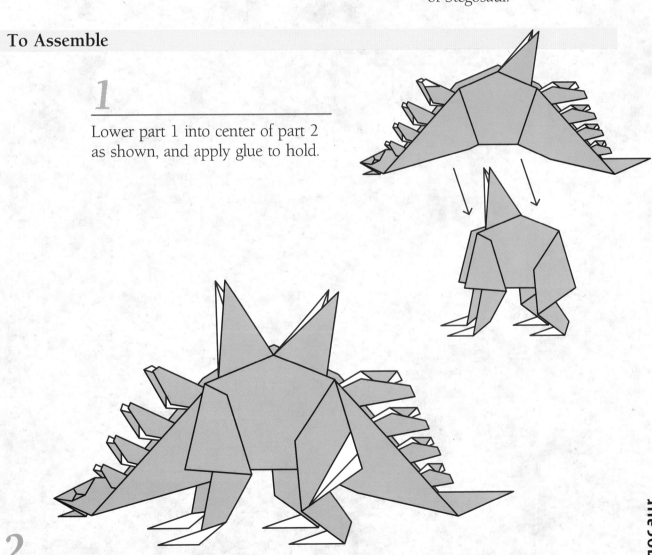

2

Completed Stegosaur.

Pteranodon

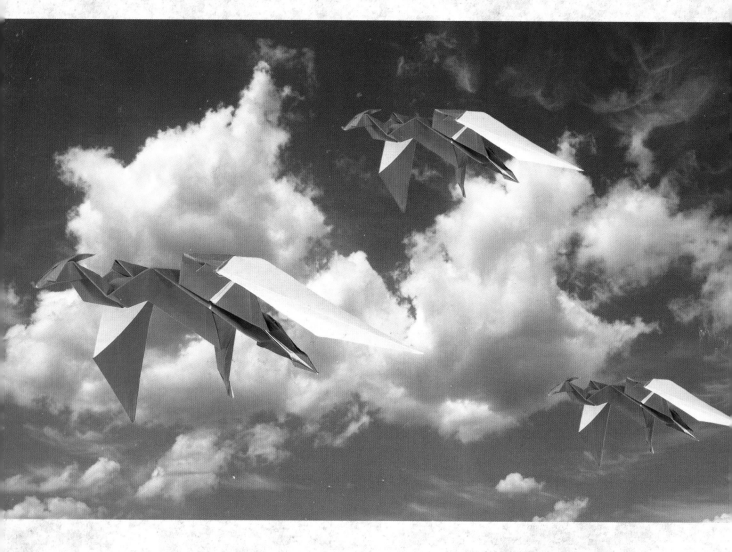

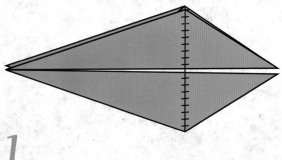

1

Start with Base Fold IV. Make cuts as shown on top layer only.

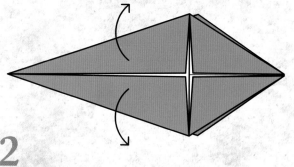

2

Valley fold cut parts.

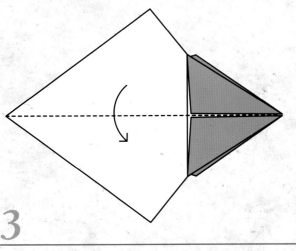

3

Valley fold.

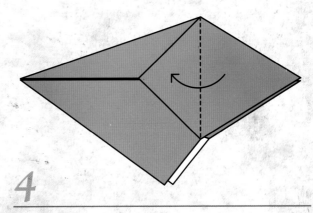

4

Valley fold.

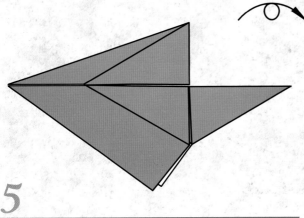

5

Turn over to the other side.

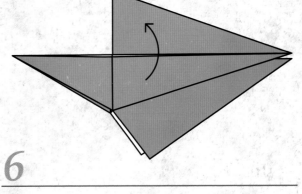

6

Valley fold.

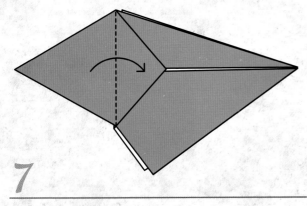

7

Valley fold.

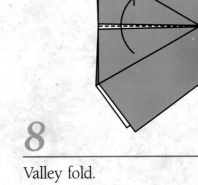

8

Valley fold.

9

Valley fold. Mountain fold flap down.

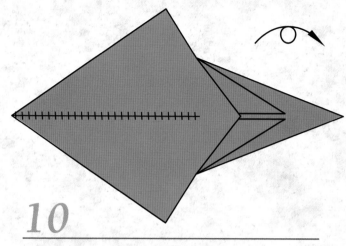

10

Make cut as shown. Turn over.

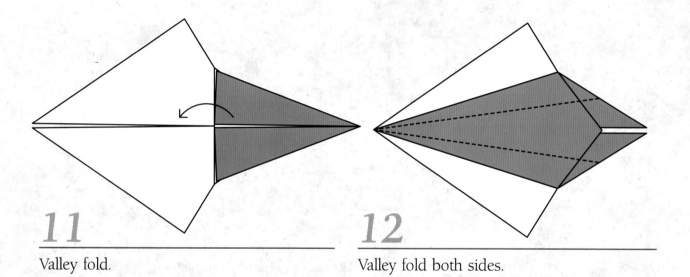

11

Valley fold.

12

Valley fold both sides.

13

Inside reverse folds.

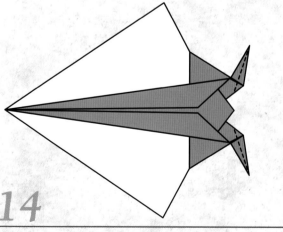

14

Valley folds all four sides.

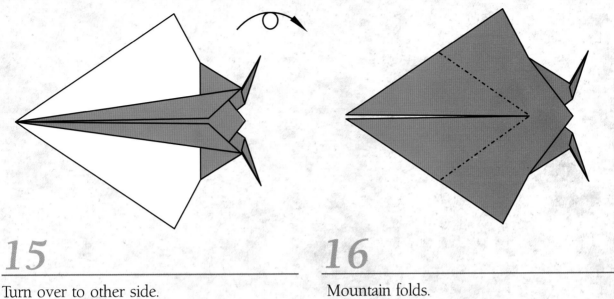

15

Turn over to other side.

16

Mountain folds.

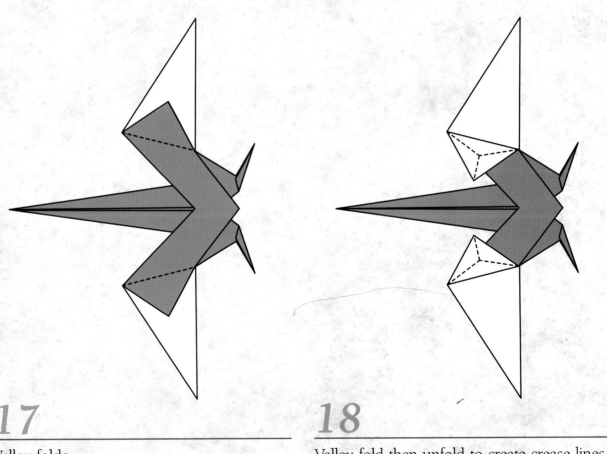

17

Valley folds.

18

Valley fold then unfold to create crease lines.

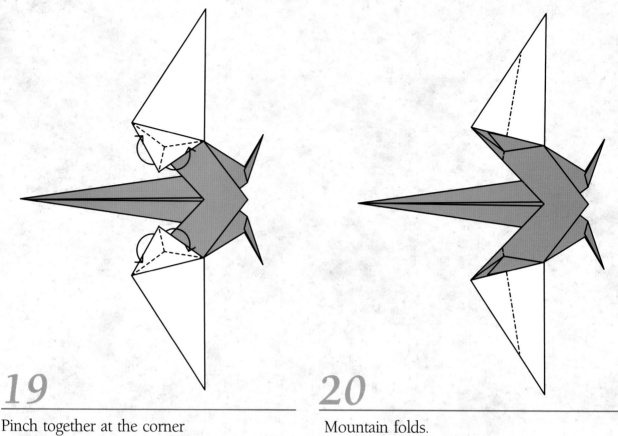

19
Pinch together at the corner
and fold inward.

20
Mountain folds.

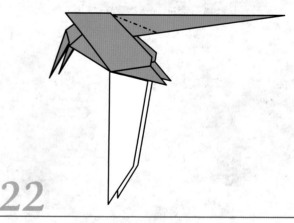

21
Mountain fold in half. Turn over.

22
Inside reverse fold.

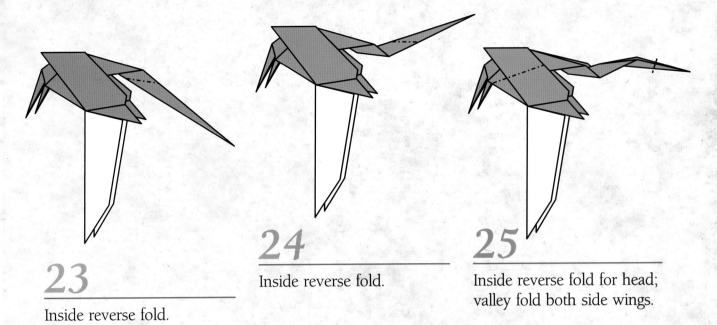

23

Inside reverse fold.

24

Inside reverse fold.

25

Inside reverse fold for head;
valley fold both side wings.

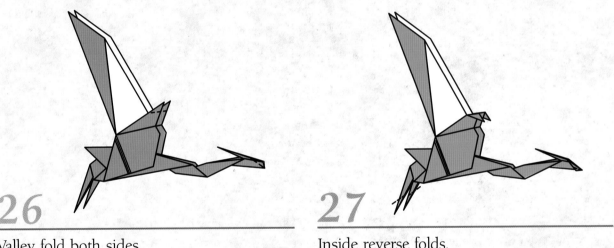

26

Valley fold both sides.

27

Inside reverse folds.

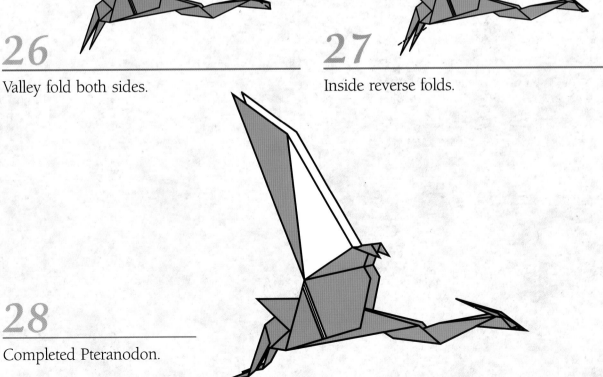

28

Completed Pteranodon.

Compsognathus

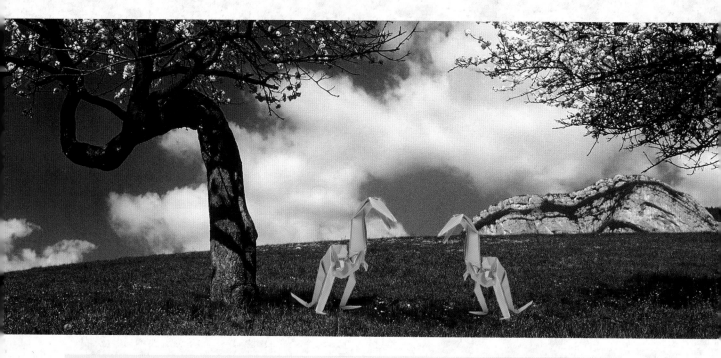

Part 1

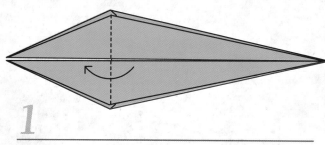

1

Start with Base Fold IV. Valley fold front and back.

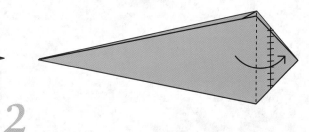

2

Cut as shown, then valley fold front and back.

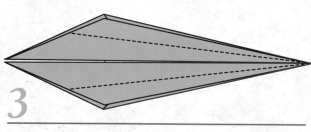

3

Valley folds.

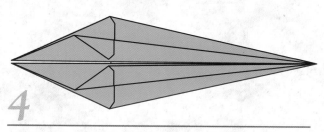

4

Turn over to other side.

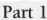

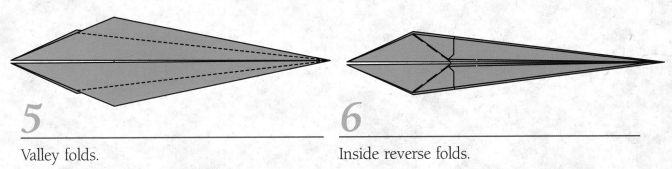

5

Valley folds.

6

Inside reverse folds.

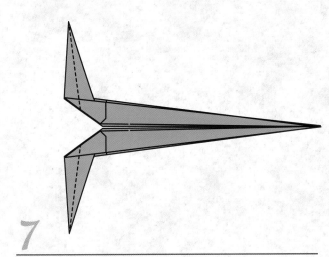

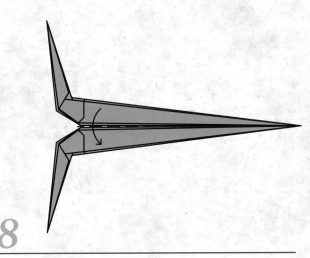

7

Valley fold both front and back.

8

Fold in half.

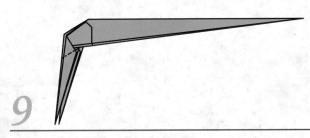

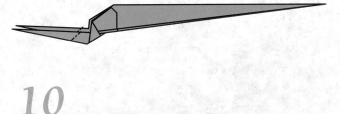

9

Inside reverse folds.

10

Inside reverse folds.

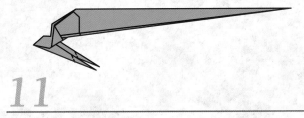

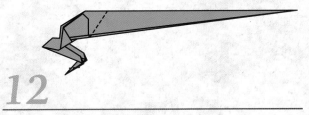

11

Inside reverse folds.

12

Outside reverse folds.

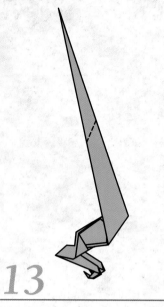

13

Outside reverse fold.

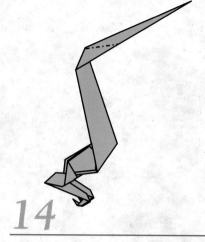

14

Inside reverse fold.

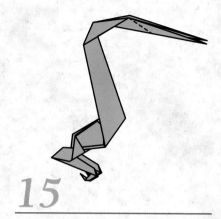

15

Outside reverse fold.

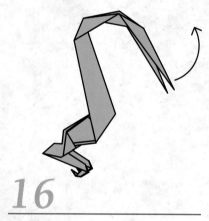

16

Pull and fold.

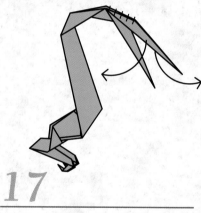

17

Cut, then open cut parts.

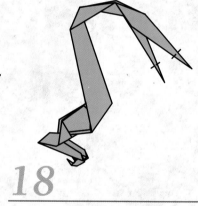

18

Outside reverse folds.

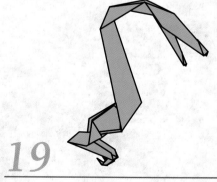

19

Completed part 1 (front) of Compsognathus.

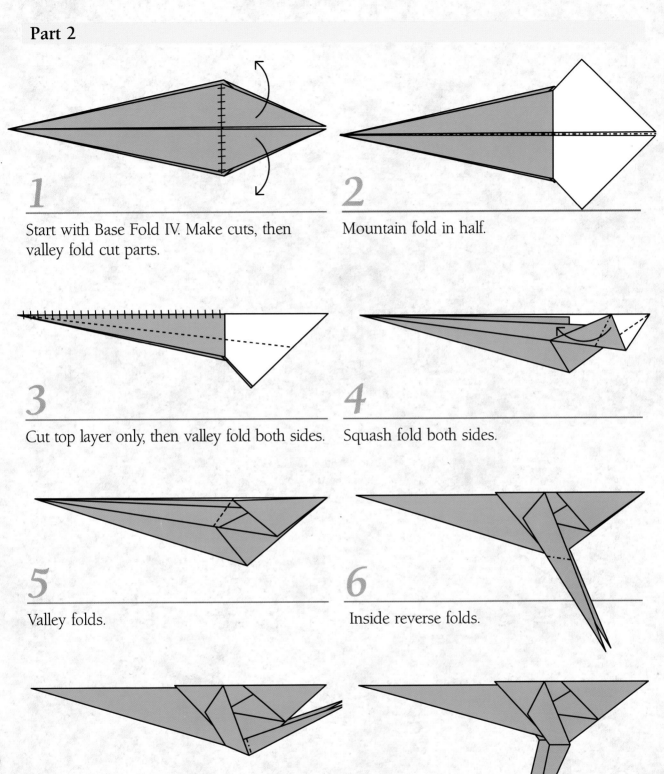

1
Start with Base Fold IV. Make cuts, then valley fold cut parts.

2
Mountain fold in half.

3
Cut top layer only, then valley fold both sides.

4
Squash fold both sides.

5
Valley folds.

6
Inside reverse folds.

7
Inside reverse folds.

8
Inside reverse folds.

Compsognathus

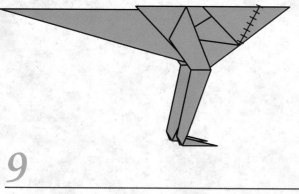

9

Make cuts as shown both front and back.

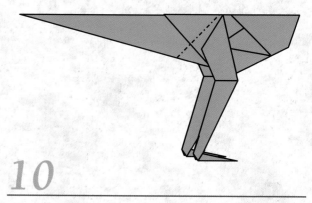

10

Inside reverse fold.

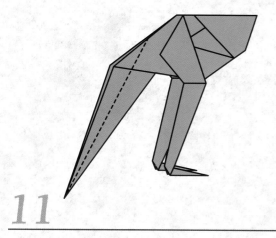

11

Valley folds, both sides.

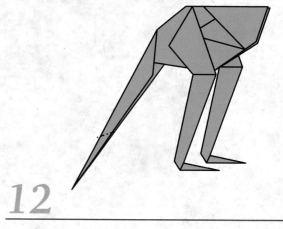

12

Inside reverse fold.

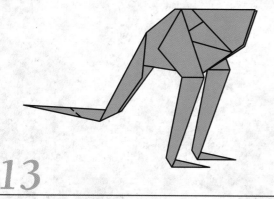

13

Outside reverse fold.

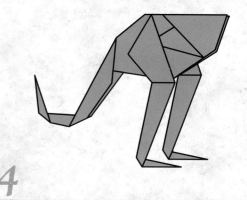

14

Completed part 2 (rear) of Compsognathus.

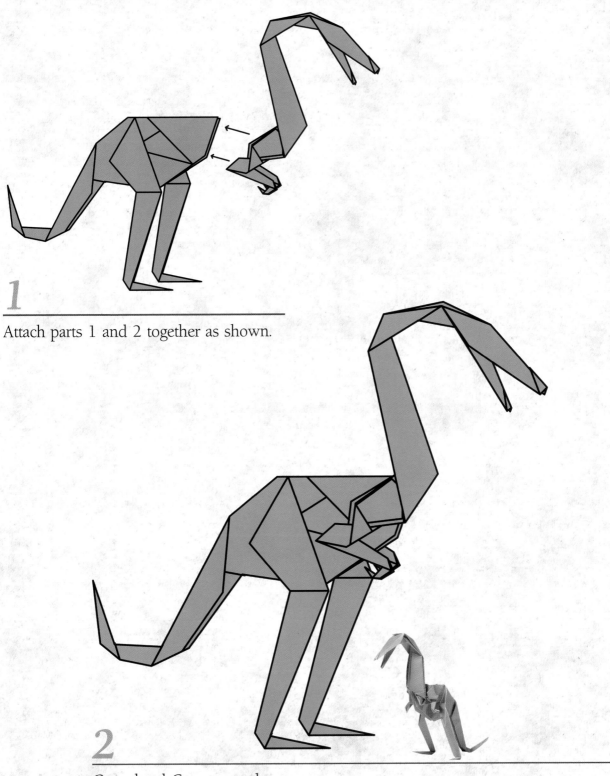

1

Attach parts 1 and 2 together as shown.

2

Completed Compsognathus.

Muraenosaur

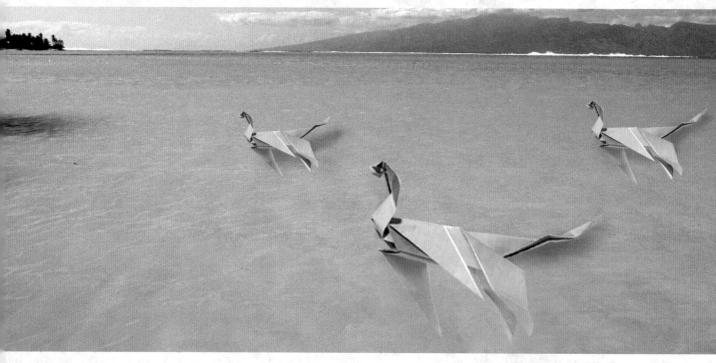

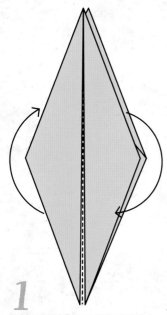

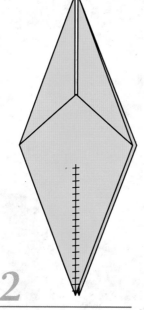

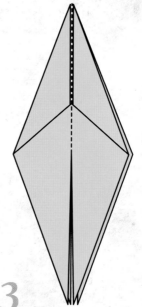

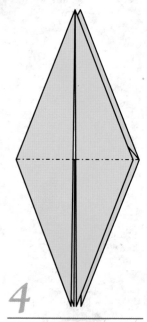

1 Start with Base Fold III. Valley folds front and back.

2 Cut front and back as shown.

3 Valley fold both sides.

4 Mountain fold bottom two flaps.

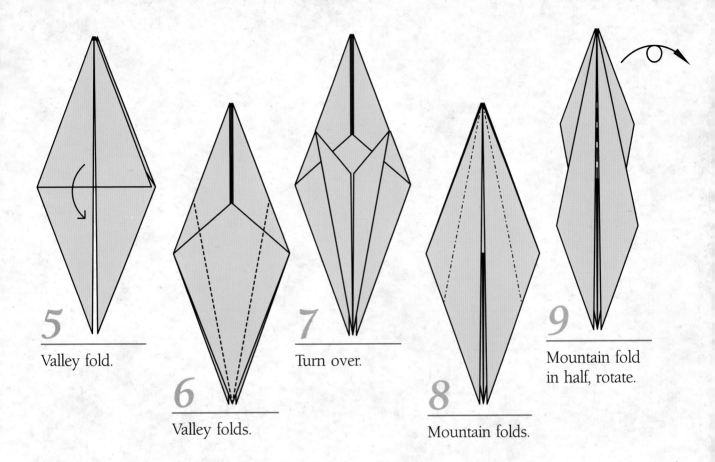

5
Valley fold.

6
Valley folds.

7
Turn over.

8
Mountain folds.

9
Mountain fold
in half, rotate.

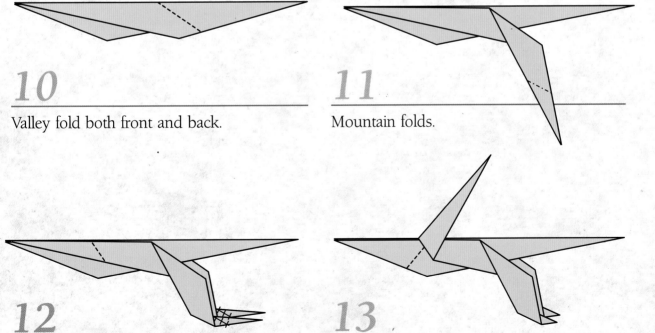

10
Valley fold both front and back.

11
Mountain folds.

12
Cut as shown, then outside reverse fold.

13
Valley folds front and back.

Muraenosaur

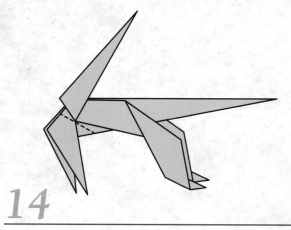

14

Valley fold front and back.

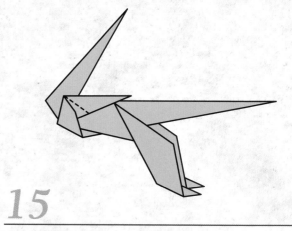

15

Valley fold front and back.

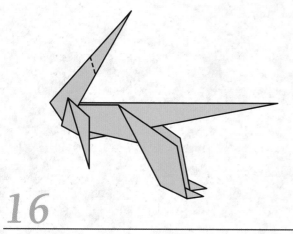

16

Inside reverse fold.

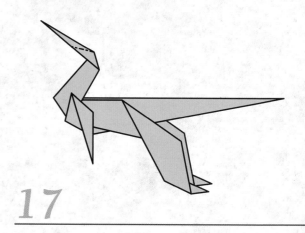

17

Outside reverse fold.

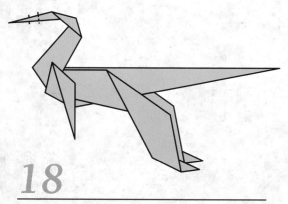

18

Open fold slightly, pleat and refold. Now see close-ups for head folds.

19

Valley fold both front and back.

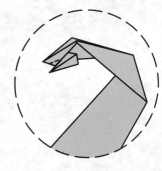

20

Valley fold upward, both front and back.

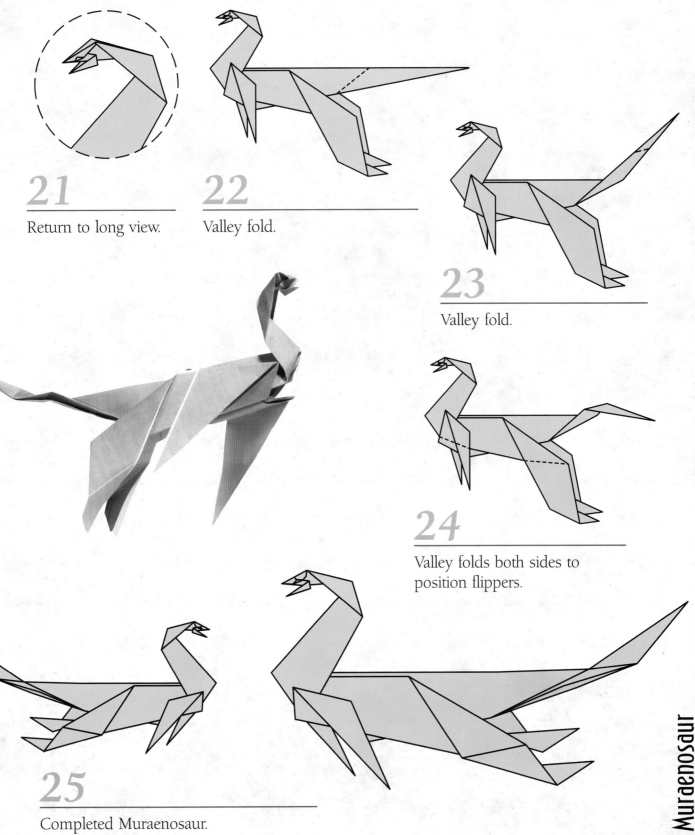

21

Return to long view.

22

Valley fold.

23

Valley fold.

24

Valley folds both sides to position flippers.

25

Completed Muraenosaur.

Parasaurolophus

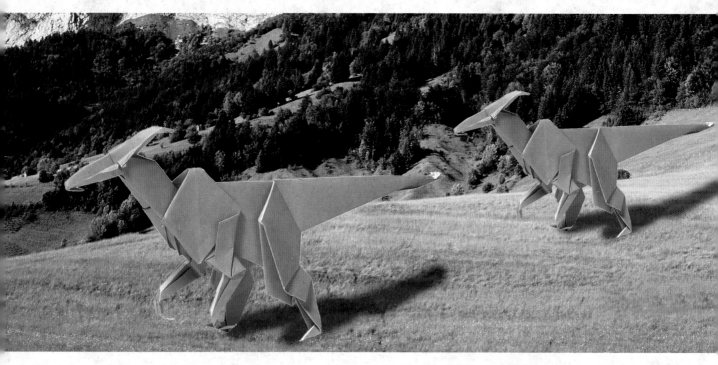

Part 1

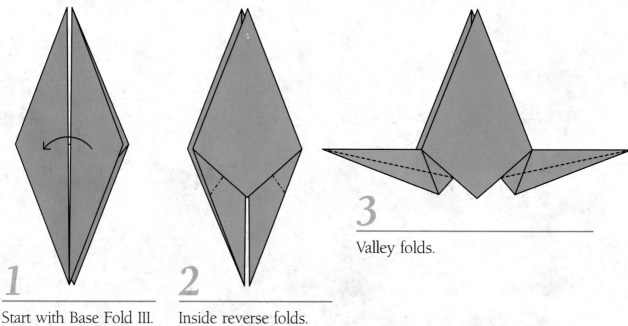

1 Start with Base Fold III. Valley fold both sides.

2 Inside reverse folds.

3 Valley folds.

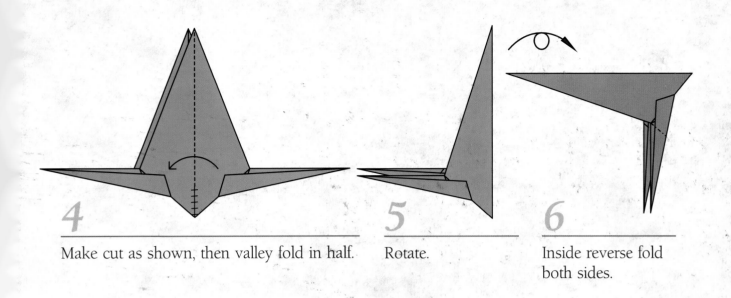

4
Make cut as shown, then valley fold in half.

5
Rotate.

6
Inside reverse fold both sides.

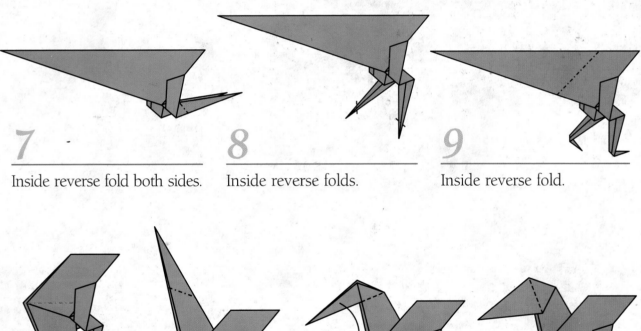

7
Inside reverse fold both sides.

8
Inside reverse folds.

9
Inside reverse fold.

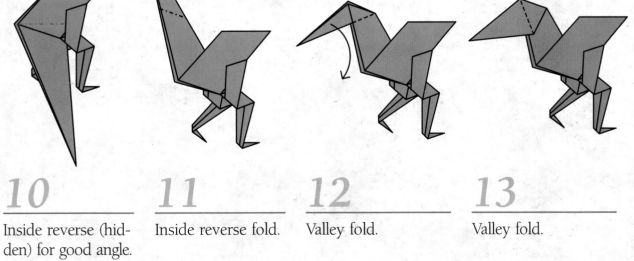

10
Inside reverse (hidden) for good angle.

11
Inside reverse fold.

12
Valley fold.

13
Valley fold.

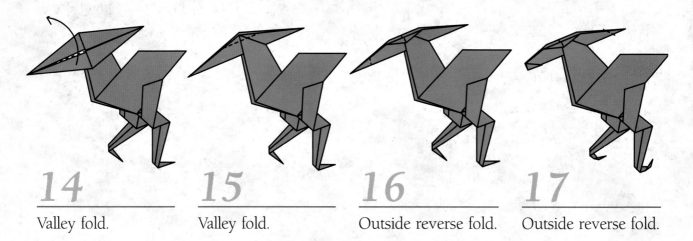

14
Valley fold.

15
Valley fold.

16
Outside reverse fold.

17
Outside reverse fold.

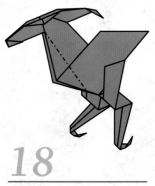

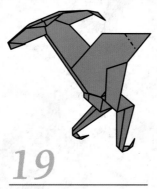

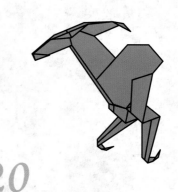

18
Mountain fold both sides.

19
Mountain fold both sides.

20
Completed part 1 (front) of Parasaurolophus.

Part 2

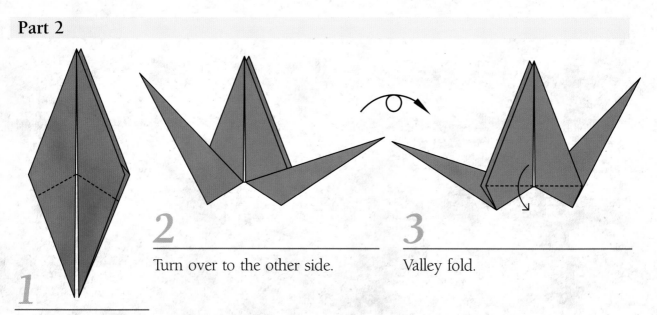

1
Start with Base Fold III. Valley folds.

2
Turn over to the other side.

3
Valley fold.

Parasaurolophus

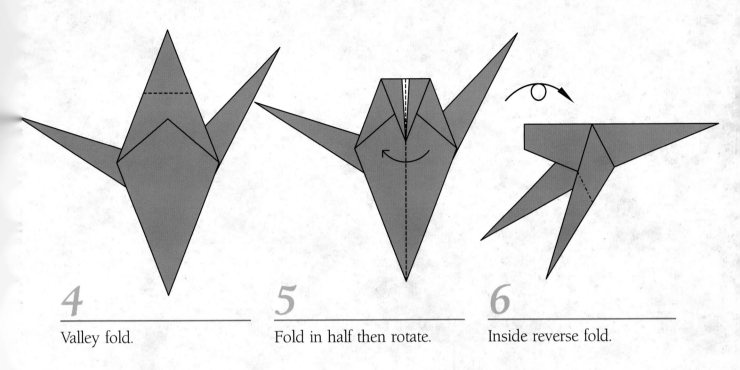

4

Valley fold.

5

Fold in half then rotate.

6

Inside reverse fold.

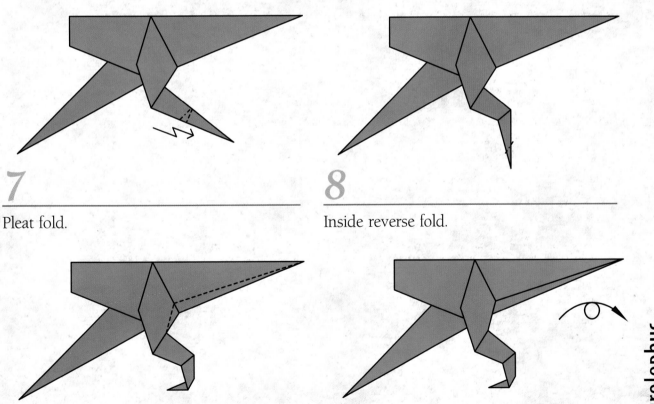

7

Pleat fold.

8

Inside reverse fold.

9

Inside reverse upper leg, mountain fold tail.

10

Turn over.

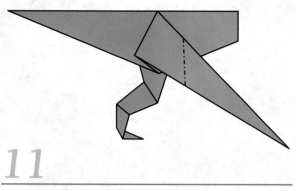

11

Inside reverse fold.

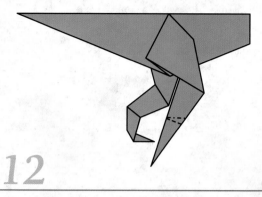

12

Pleat fold.

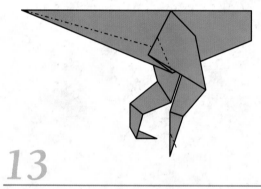

13

Inside reverse fold upper leg and mountain fold tail. Inside reverse fold foot.

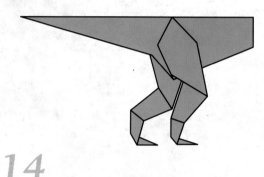

14

Completed part 2 (rear) of Parasaurolophus.

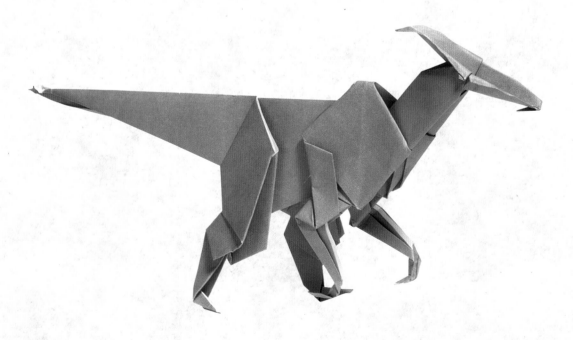

To Assemble

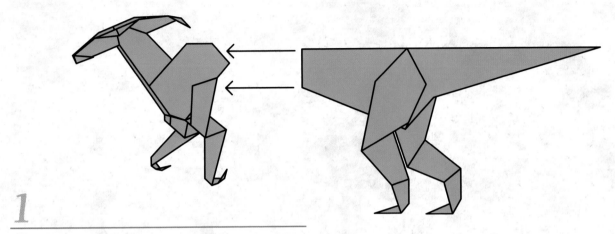

1

Join both parts together as indicated by the arrows, then apply glue to hold.

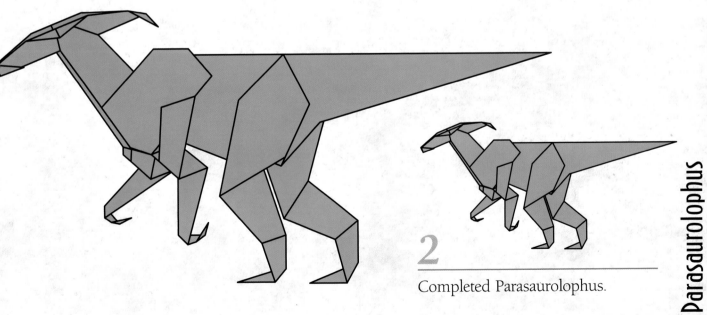

2

Completed Parasaurolophus.

Pachycephalosaur

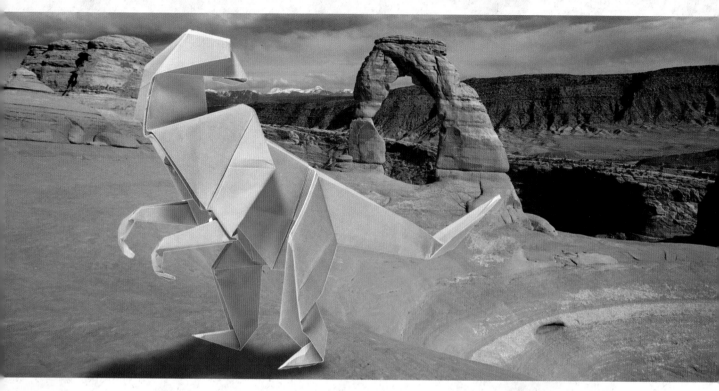

Part 1

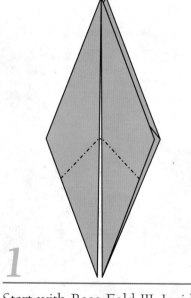

1

Start with Base Fold III. Inside reverse folds.

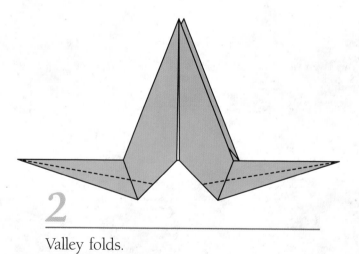

2

Valley folds.

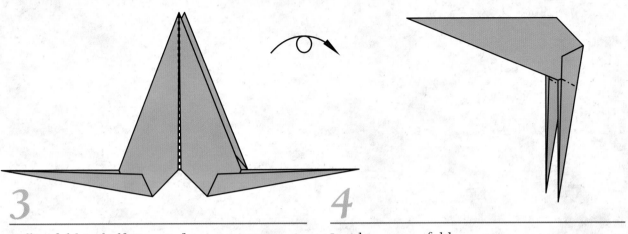

3

Valley fold in half. Rotate form.

4

Inside reverse fold.

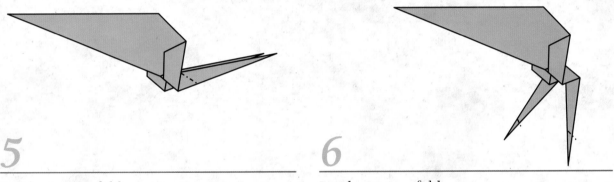

5

Inside reverse fold.

6

Inside reverse fold.

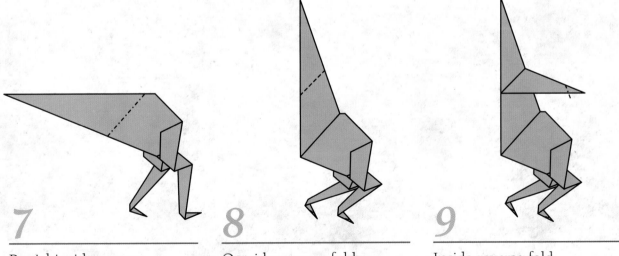

7

Partial inside reverse, crimping upwards.

8

Outside reverse fold.

9

Inside reverse fold.

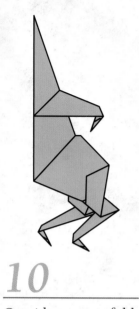

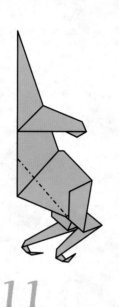

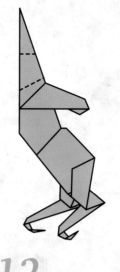

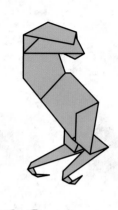

10

Outside reverse fold.

11

Mountain fold.

12

Outside reverse fold, then outside reverse again.

13

Completed part 1 (front) of Pachycephalosaurs.

Part 2

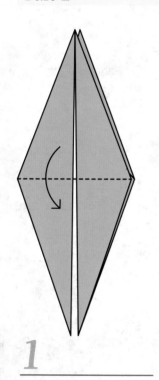

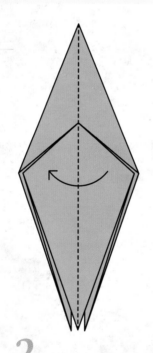

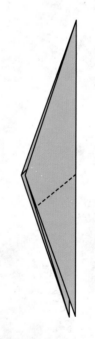

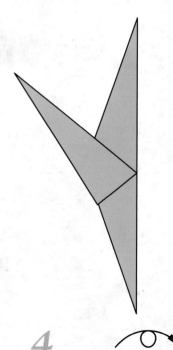

1

Start with Base Fold III. Valley fold.

2

Valley fold in half and rotate.

3

Valley fold front and back.

4

Rotate.

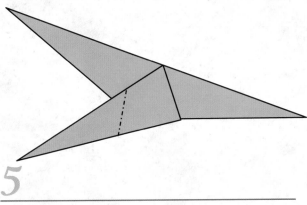

5

Inside reverse fold.

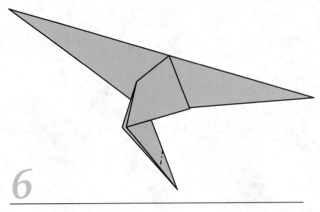

6

Inside reverse fold.

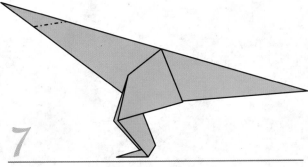

7

Inside reverse fold.

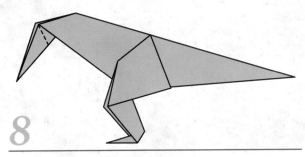

8

Outside reverse fold.

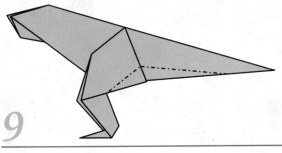

9

Inside reverse fold leg, then mountain fold tail.

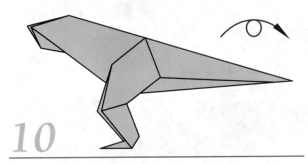

10

Turn over to other side.

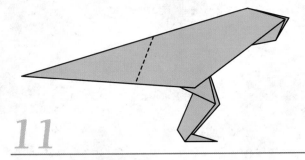

11

Valley fold.

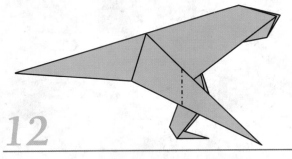

12

Inside reverse fold.

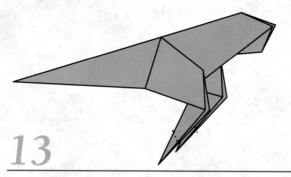

13

Inside reverse folds.

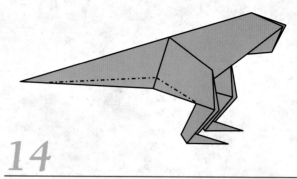

14

Inside reverse fold upper leg, then mountain fold tail.

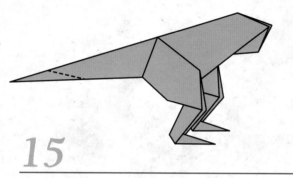

15

Outside reverse fold.

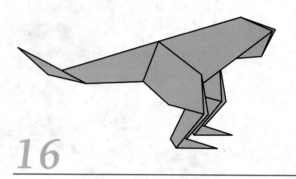

16

Completed part 2 (rear) of Pachycephalosaur.

To Assemble

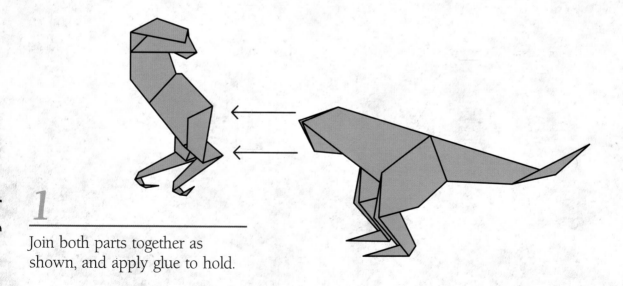

1

Join both parts together as shown, and apply glue to hold.

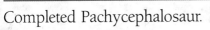

2

Completed Pachycephalosaur.

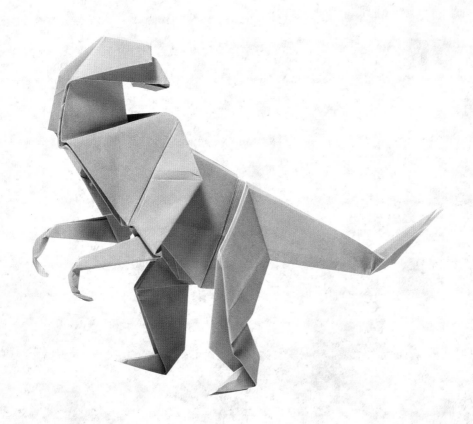

Ankylosaur

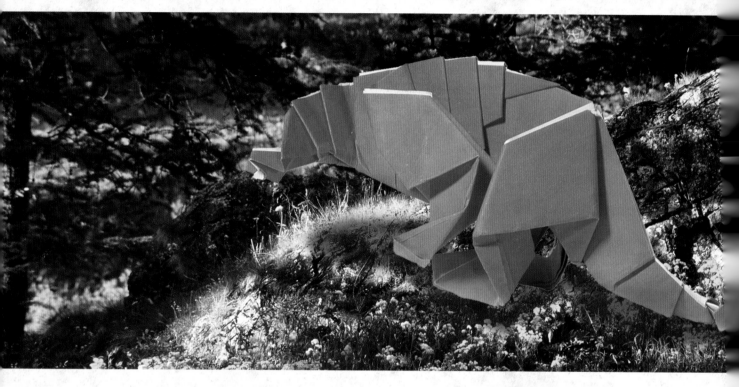

Part 1

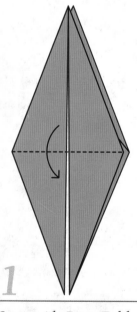

1

Start with Base Fold III. Valley fold.

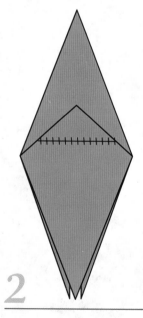

2

Cut as shown.

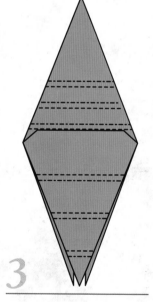

3

Pleat folds.

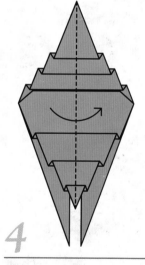

4

Fold in half, then rotate.

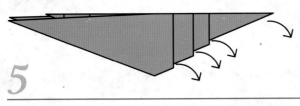

5

Pull in direction of arrows and squash fold.

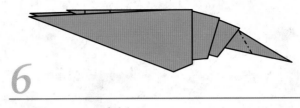

6

Inside reverse fold.

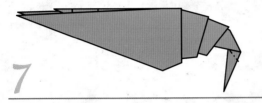

7

Inside reverse fold.

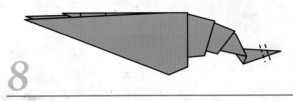

8

Pleat fold.

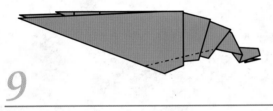

9

Mountain fold front and back.

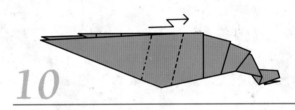

10

Pleat front and back.

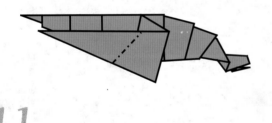

11

Inside reverse folds front and back.

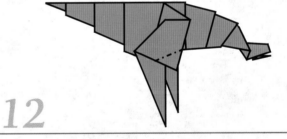

12

Inside reverse folds front and back.

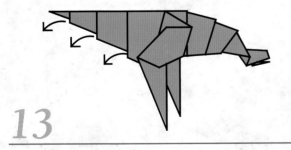

13

Pull and squash fold to shape.

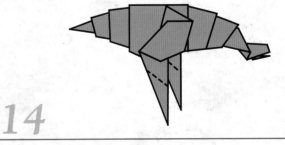

14

Outside reverse folds.

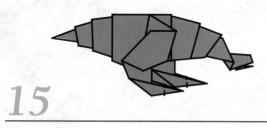

15

Outside reverse folds.

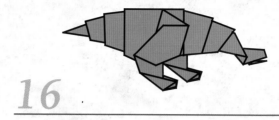

16

Completed part 1 (front) of Ankylosaur.

Part 2

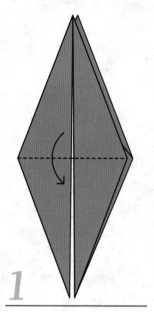

1

Start with Base Fold III. Valley fold.

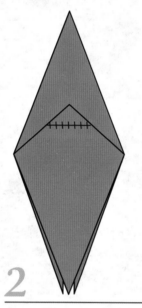

2

Cut as shown.

3

Cut as shown.

4

Valley fold in half, then rotate.

5

Valley fold front and back.

6

Pull in direction of arrow, and squash fold.

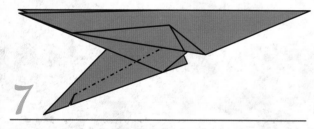

7

Mountain folds front and back.

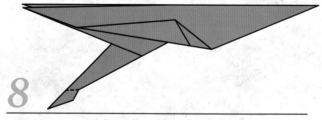

8

Outside reverse fold.

Ankylosaur

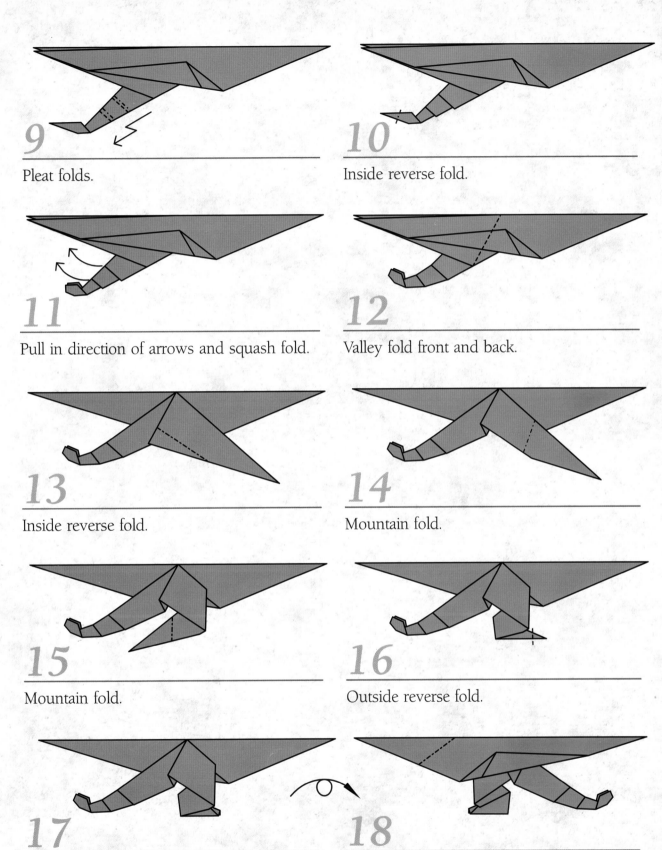

9

Pleat folds.

10

Inside reverse fold.

11

Pull in direction of arrows and squash fold.

12

Valley fold front and back.

13

Inside reverse fold.

14

Mountain fold.

15

Mountain fold.

16

Outside reverse fold.

17

Turn over to the other side.

18

Inside reverse fold, then repeat steps 12 to 17.

Ankylosaur

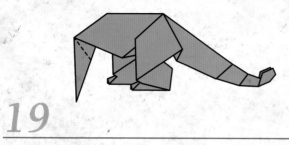

19

Outside reverse fold.

20

Complete part 2 (rear) of Ankylosaur.

To Assemble

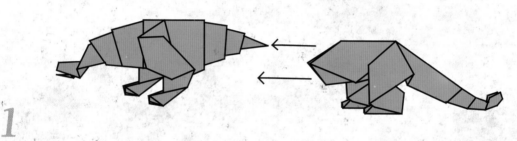

1

Join both parts together as indicated by the arrows and apply glue to hold.

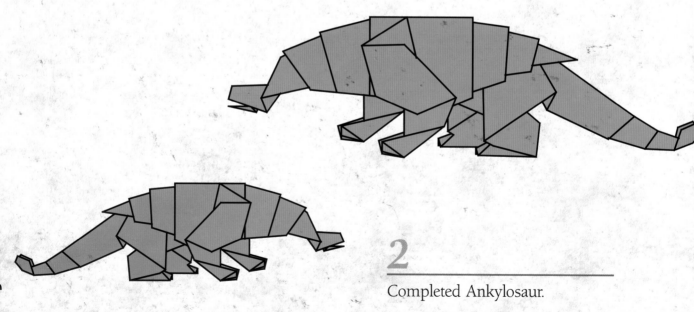

2

Completed Ankylosaur.

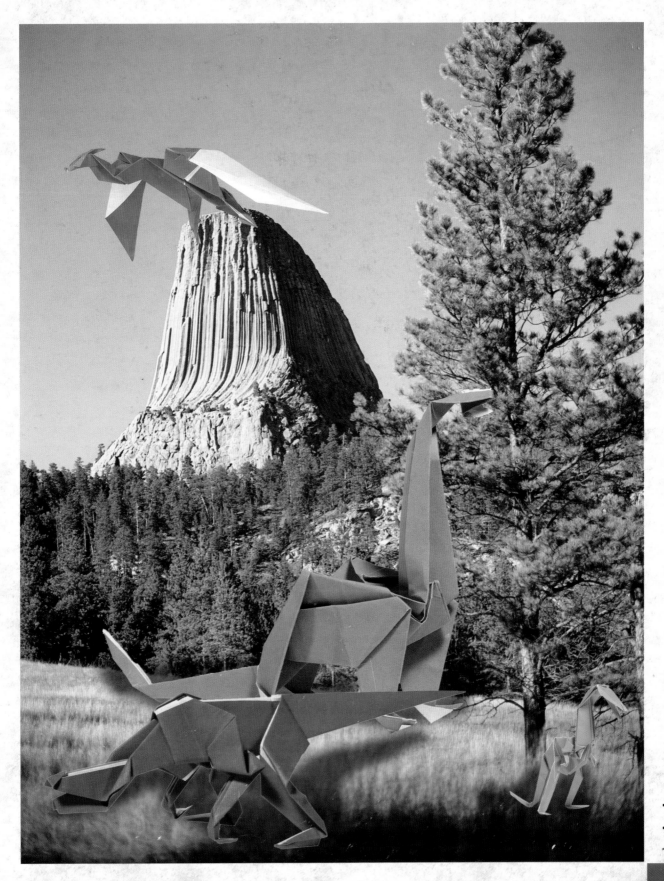

Fantasy Dilophosaur

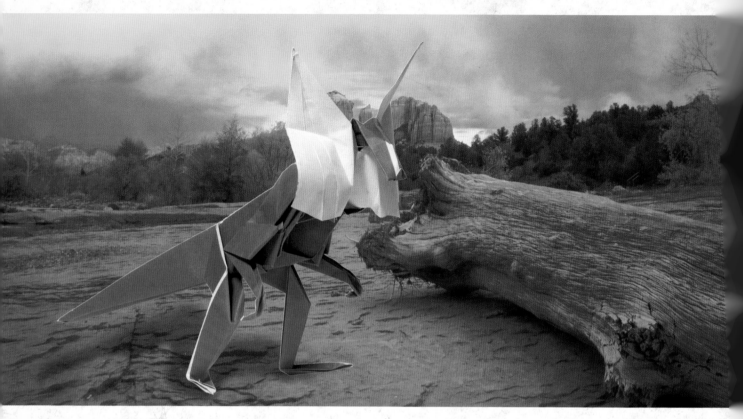

Part 1

1

Start with Base Fold III. Inside reverse folds.

2

Mountain folds.

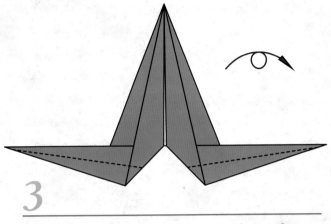

3

Valley folds, then turn over to other side.

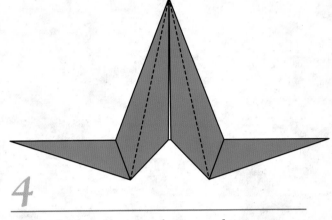

4

Valley folds left and right toward center.

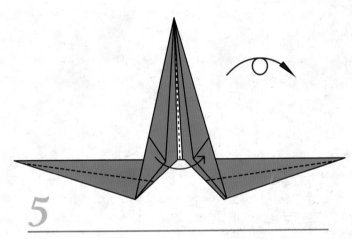

5

Valley fold left and right side. Valley fold in half then rotate.

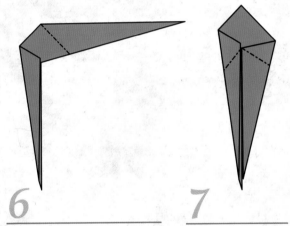

6

Inside reverse fold.

7

Inside reverse folds.

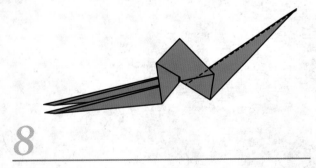

8

Valley fold.

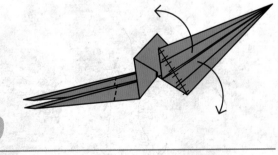

9

Cut as shown then valley fold cut parts. Inside reverse fold legs.

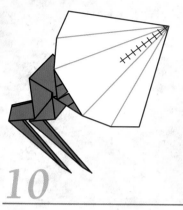

10

Cut as shown.

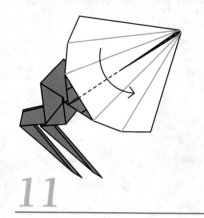

11

Valley fold.

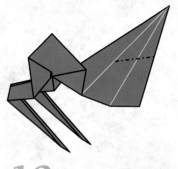

12

Mountain fold both sides.

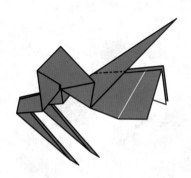

13

Inside reverse fold.

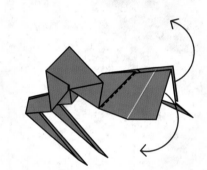

14

Pull down on flaps to loosen folds, then valley fold in the direction of arrows.

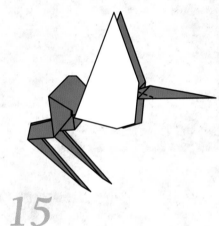

15

Outside reverse fold.

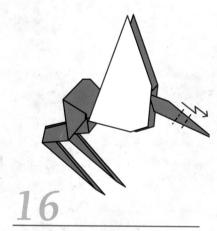

16

Pleat fold.

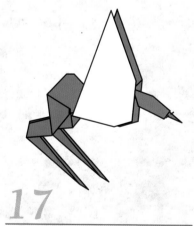

17

Outside reverse fold.

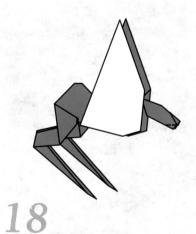

18

Now mountain fold.

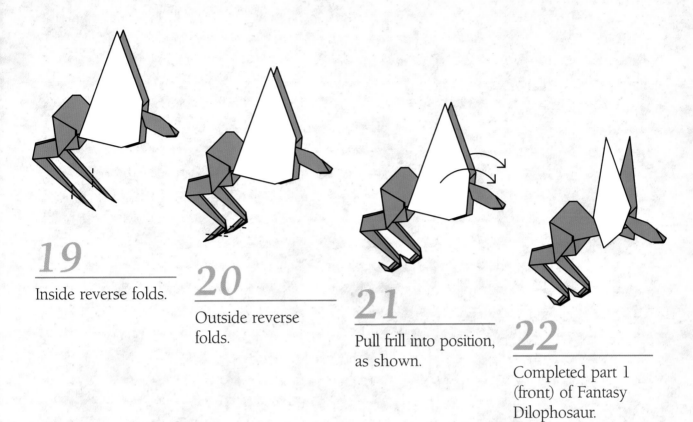

19

Inside reverse folds.

20

Outside reverse folds.

21

Pull frill into position, as shown.

22

Completed part 1 (front) of Fantasy Dilophosaur.

Part 2

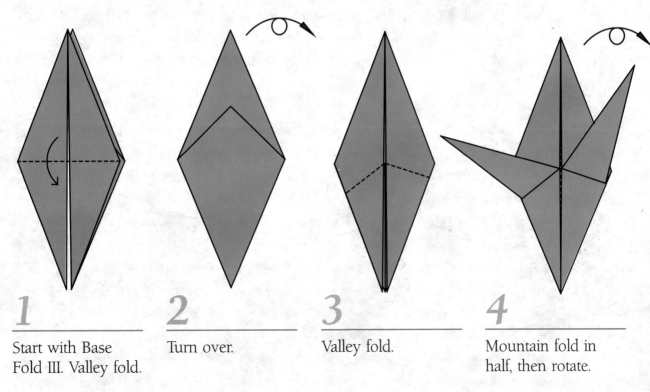

1

Start with Base Fold III. Valley fold.

2

Turn over.

3

Valley fold.

4

Mountain fold in half, then rotate.

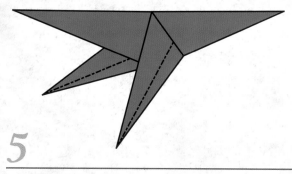

5

Inside reverse folds front and back.

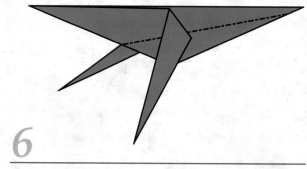

6

Mountain fold both front and back.

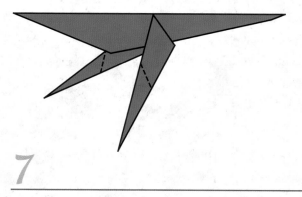

7

Outside reverse fold both sides.

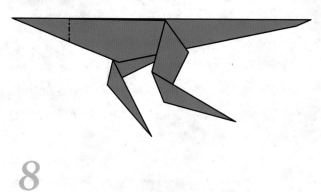

8

Inside reverse fold.

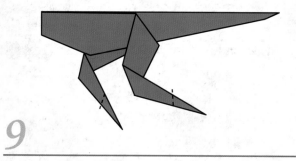

9

Outside reverse folds.

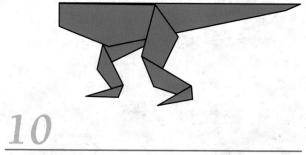

10

Completed part 2 (rear)
of Fantasy Dilophosaurus.

To Assemble

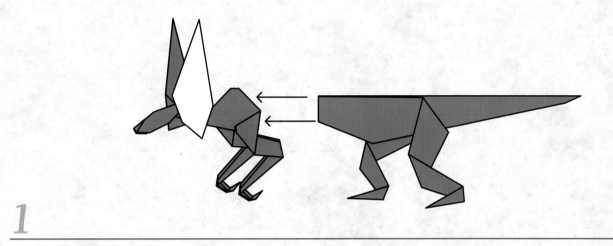

1

Join both parts together as shown, and apply glue to hold.

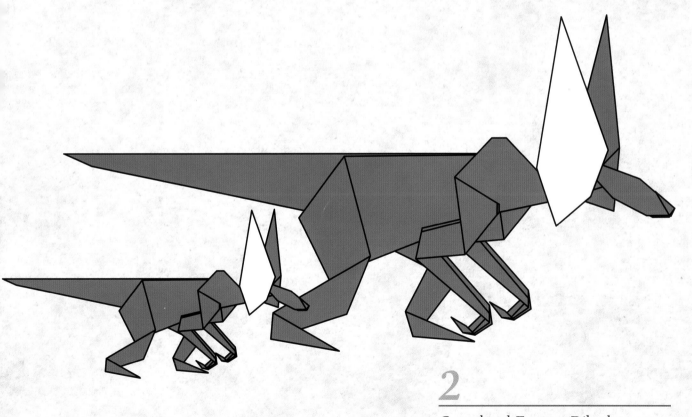

2

Completed Fantasy Dilophosaur.

Barosaur

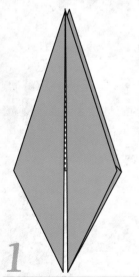

1 Start with Base Fold IV and valley fold front and back.

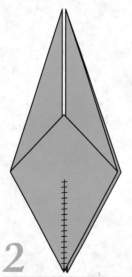

2 Cut as shown front and back.

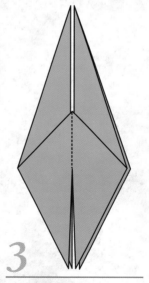

3 Valley fold front and back.

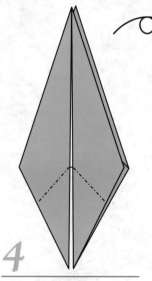

4 Mountain fold left and right, and rotate.

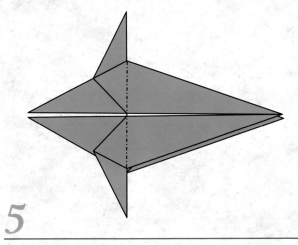

5

Mountain folds.

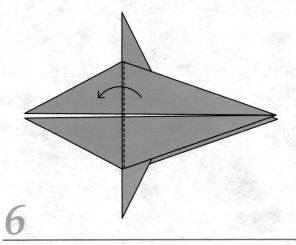

6

Valley fold in direction of the arrow.

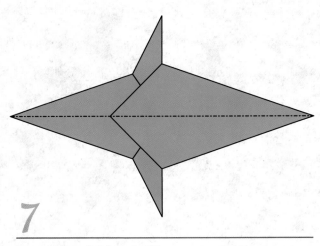

7

Mountain fold in half.

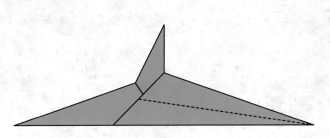

8

Valley fold both sides.

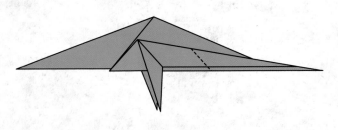

9

Outside reverse fold.

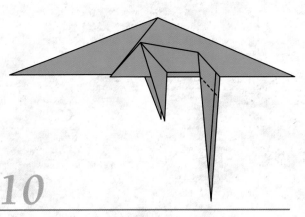

10

Outside reverse fold.

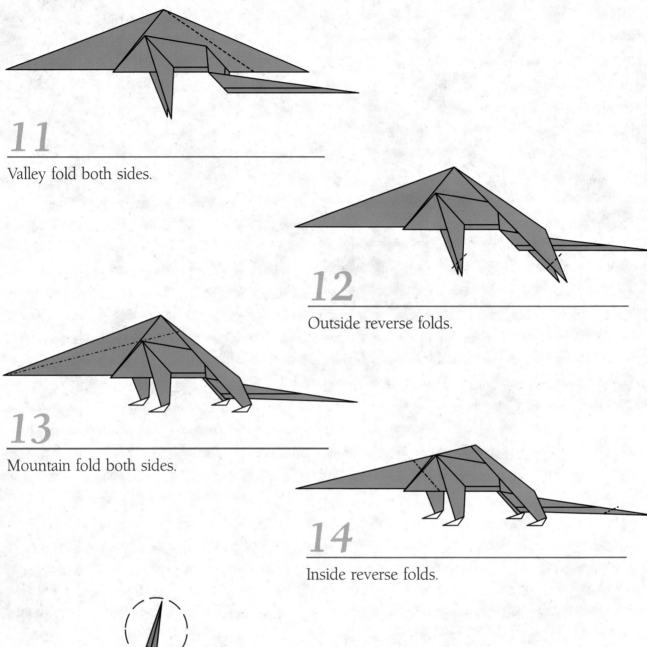

11

Valley fold both sides.

12

Outside reverse folds.

13

Mountain fold both sides.

14

Inside reverse folds.

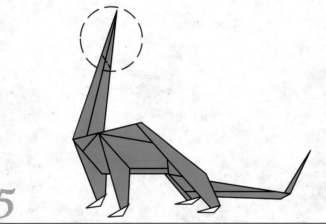

15

Inside reverse fold, then see close-up for head details.

16

Outside reverse fold.

17

Pleat fold.

18

Head completed, to full view.

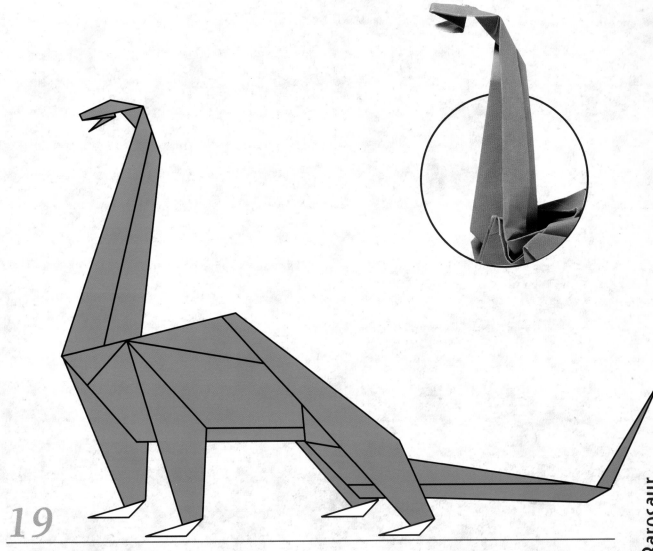

19

Completed Barosaur.

Dino Notes

Ankylosaur, a vegetarian, would swallow plants whole and digest them in its huge stomach. **Barosaur**, also a plant-eater, had a long, sinewy neck so he could see predators approaching from far off. **Brontosaur**, a name no longer used by the scientific community, is correctly known by its original name, Apatosaurus. **Compsognathus** was small, only the size of a chicken. **Fantasy dilophosaur** was creatively altered (genetically engineered?) for its movie role: "real" dilophosaurs were larger-size predators that had no "pop-up" frill. **Muraenosaur** is actually a type of plesiosaur, a sea-going lizard and not a dinosaur. **Pachycephalosaur**, was named for its thick, dome-shaped head·covering. **Parasaurolophus**, a large plant-eater, had a long hollow head crest and a ducklike bill. **Pelycosaur**, actually a reptile with a back sail, went extinct before dinosaurs even evolved. **Pteranodon**, a flying reptile, used its wide wings to soar on air currents as it hunted for food. **Stegosaur** had several sets of large, vertical plates running down its back from head to tail. **Triceratops**, recognized by its three facial horns, was one of the last dinosaurs to become extinct. **Tyrannosaur**, the tyrant dinosaur "king," had a very large brain, and very short arms. **Velociraptor** was small compared to other dinosaurs and very quick; the fierce meat-eater would steal food, but also attack larger prey.

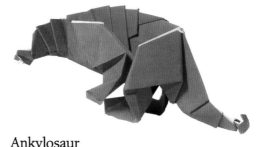

Ankylosaur

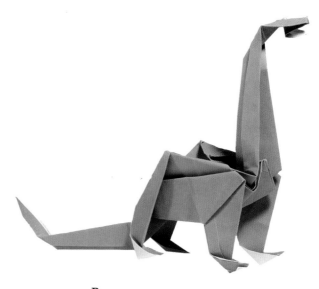

Barosaur

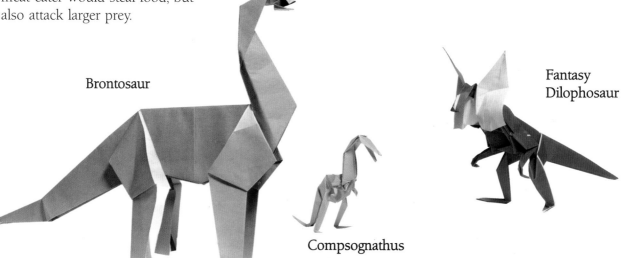

Brontosaur

Compsognathus

Fantasy Dilophosaur

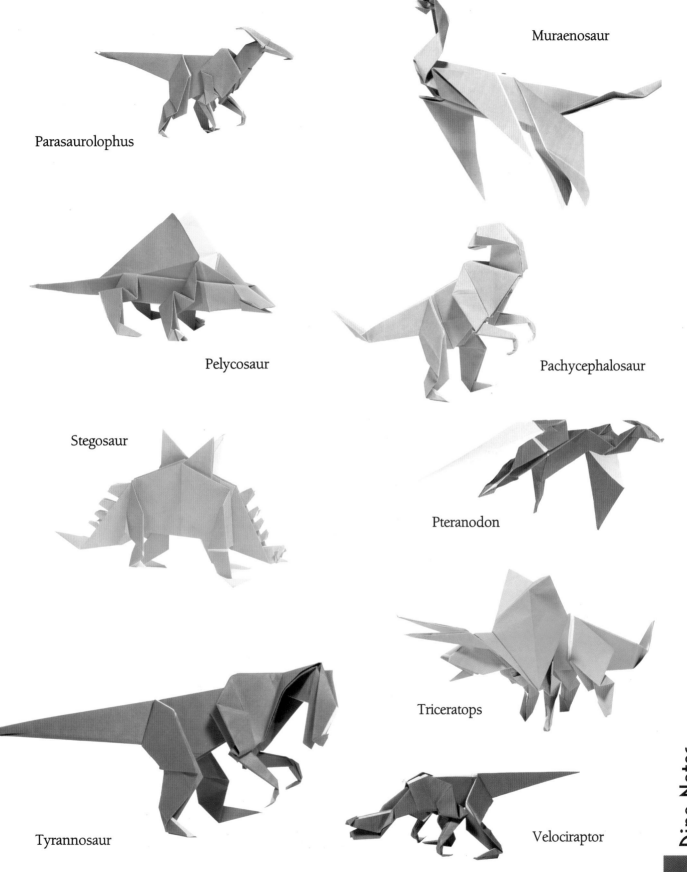

Parasaurolophus

Muraenosaur

Pelycosaur

Pachycephalosaur

Stegosaur

Pteranodon

Triceratops

Tyrannosaur

Velociraptor

Index